The Return of the Gods
Neoclassical Sculpture in Britain

Marjorie Trusted

Tate Publishing

First published 2008 by order of the
Tate Trustees
by Tate Publishing, a division of Tate
Enterprises Ltd,
Millbank, London SW1P 4RG
www.tate.org.uk/publishing

on the occasion of the exhibition
The Return of the Gods
Neoclassical Sculpture in Britain
Tate Britain, London
28 January – 1 June 2008

Exhibition supported by The Henry
Moore Foundation

Tate Publishing would like to
acknowledge the support of the Paul
Mellon Centre for Studies in British
Art.

British Library Cataloguing in
Publication Data
A catalogue record for this book is
available from the British Library

ISBN 978-1-85437-765-4

Library of Congress Cataloging in
Publication Data
Library of Congress Control
Number: 2007940501

Designed by Matt Brown
at DesignBranch and
Esterson Associates
Printed by C.S. Graphics

Cover: John Gibson, *Narcissus* 1838
(no.12, detail)
Front section of the catalogue: no.5
(detail), no.21 (detail), no.22 (detail),
no.2 (detail), no.12 (detail), no.26
(detail), no.17 (detail), no.19 (detail),
no.7 (detail)

For my son, Thomas

Contents

Foreword

The Return of the Gods: Neoclassical Sculpture in Britain presents a selection of the very finest works of sculpture produced by British artists or for British patrons between about 1760 and 1860, all focusing on the idealised representation of the human form. Together, they exemplify a period of particular energy, inventiveness and innovation in British art inspired by the celebrated works of ancient Greece and Rome. The style represented in these objects has traditionally been known as 'Neoclassicism'. Like many art-historical labels, this was originally coined as a term of abuse, and in this case was intended to refer to a decorative style that was perceived by the later nineteenth century to be affected and superficial. Yet it has become the standard term for describing the new imaginative involvement with the antique and its values among artists, collectors and critics in the late eighteenth century, which was expressed most powerfully in the form of sculpture. During the period covered by this exhibition, British patrons and British artists were at the leading edge of this renewed engagement with the classical past. The marble sculptures in this display are among the finest productions in this medium in the history of art, and deserve to be better known and appreciated.

A number of recent scholars – Malcolm Baker, James Hall and Alex Potts amongst them – have explored the 'problem' presented by sculpture in terms of both museum display and the history of art. Today's gallery spaces are generally far removed from the original environments which hosted sculptures in the past, and the way we experience them in modern art galleries may be slightly misleading. Most of the sculptures here were originally meant to be seen in refined interior settings, in environments that encouraged an intimate, even passionate, emotional involvement. A number were, in fact, destined for specially-designed galleries within grand town and country houses. For the first time in the late eighteenth century, British sculptors were being encouraged to create sculptures that were intended to be enjoyed quite self-consciously for their aesthetic qualities and technical accomplishment. Reproductive images and copies, meanwhile, provided a means by which knowledge and appreciation of these objects were extended to a wider realm, enabled by the developing commercial acumen of producers and distributors, and in response to a ready market. Traditional ways of understanding the development of sculpture – for example in terms of the transition from 'rococo' to 'neoclassical' – are no longer entirely adequate, and this exhibition offers an opportunity to invite a wide public to engage with the subject afresh in the singular setting of the Duveen galleries at Tate Britain.

The Return of the Gods is a further stage in Tate Britain's ongoing efforts to draw sculpture more fully into the mainstream history of British art. In 2001 *Image and Idol* presented several major works of medieval sculpture, in an installation designed by the contemporary artist Richard Deacon. In the following years, a number of works of sculpture have been integrated into the displays of historic art, including significant loans from the Victoria & Albert Museum and

The Royal Academy of Arts. Individual sculptural objects have also had a role to play in many of our historic exhibitions. For instance, portrait busts provided a dignified classical counterpoint to the scurrilous likenesses provided by James Gillray in our 2001 exhibition of the caricaturist's art; classical nudes in marble and bronze enriched *Exposed: The Victorian Nude* in 2001; and sculptural representations of Reynolds provided an insight into the artist's image and reputation in the exhibition *Joshua Reynolds: The Creation of Celebrity* (2005). *The Return of the Gods* is, though, the first time that eighteenth- and early nineteenth-century sculpture has been shown in depth within the national gallery of British art, and we hope it will help establish a more central role for the medium within British art history and Tate Britain itself.

The show has been carefully selected by Marjorie Trusted, Senior Curator of Sculpture at the V&A, together with Tim Knox, Director of the Sir John Soane's Museum and Helen Dorey, Deputy Director of the Sir John Soane's Museum. Working closely with Martin Myrone, Curator of Eighteenth and Nineteenth Century Art at Tate Britain, who has led the project through to realisation with the assistance of Sandra Adler, they have developed the concept of the exhibition, determined the selection of the sculptures included in the show and written the present catalogue. The exhibitions registrar was Kiko Noda, and the complex and challenging task of installing these works was managed expertly by Tate's team of art handlers and conservators, including Andy Shiel and Hattie Spires, Vanessa Griffiths, and Liam Tebbs. The editor of this superb catalogue was Alice Chasey. The installation has been designed by Adam Caruso of Caruso St John Architects, creating an environment which allows us to focus on the beauty and quality of individual sculptures and helping us to recall the sheer excitement experienced by their first viewers. I would like to thank all these central players most warmly.

Further, we are all extremely grateful to the Henry Moore Foundation for a substantial grant towards the making of the exhibition – former director Tim Llewellyn's immediate and sustained enthusiasm for the project was crucial from the outset – and to the Paul Mellon Centre for Studies in British Art for subsidising the publication of the catalogue, which otherwise would have been much slimmer. Amongst our generous lenders, the V&A and National Galleries of Scotland must be thanked for their great generosity in parting temporarily with Canova's *Three Graces*, and we are indebted to Alastair Laing and the National Trust for wholehearted support on all fronts.

Stephen Deuchar
Director, Tate Britain

Introduction
The Return of the Gods

Rome

In 1826 the Scottish painter David Wilkie (1785–1841) wrote from Rome to a friend, 'But it is sculpture here that is the great object of attention and encouragement. The numbers of hewers and cutters multiply by every day's further knowledge of Rome: the chisel and hammer are heard in every corner … statues and groups are growing to life with almost faultless form …'[1] Marble sculpture was the pre-eminent European art form from 1770 onwards, dwarfing the tamer art of painting. The ongoing excavations and discoveries of major classical statuary, the widespread patronage and collecting of sculpture, especially by British Grand Tourists, as well as the lively interest in classical scholarship, meant that the thrill and excitement of sculpture was at its peak. Mythological gods, sumptuous nudes, classical motifs and styles – revered and studied since the Renaissance – had returned in earnest. Over half the sculptures in this exhibition were made in Rome, where all the sculptors represented here spent time studying and training, and where many of them ultimately settled permanently. Just as the Grand Tour became a virtual imperative for British gentlemen in the eighteenth century, so a period of study in Italy was deemed to be almost indispensable for a young British artist from the mid-eighteenth to the mid-nineteenth century and beyond. Sculpture dominated the stage, inspiring rapt and emotional responses; it was also seen as exquisitely sensuous. Canova's friend and admirer, the writer Leopoldo Cicognara (1767–1834), said of the statue of *Paris* that Canova made for the Empress Josephine, 'if statues could be made by stroking marble rather than by roughly cutting and chipping, I would say that this one had been formed by wearing down the surrounding marble by dint of kisses and caresses.'[2]

Restorations and copies of antique sculpture

British aristocrats and wealthy gentlemen visiting the Eternal City were usually struck first and foremost by the antique ruins and remains. Within these larger 'ruinscapes' fragmentary statues and architectural details, often imaginatively restored by Italian and British sculptors, were avidly collected. Bartolomeo Cavaceppi (1716–1799) was one of the leading restorers, and his works were much coveted, as were the confections of antique fragments and modern additions, especially vases, designed by Giovanni Battista Piranesi (1720–1778).[3] Reservations began to be expressed about restorations in the late eighteenth century, and some ancient works were not repaired or restored. The most famous of these was the *Belvedere Torso*, believed to be a fragment of a monumental statue of Hercules (or Herakles), now in the Vatican (fig. 1). Not only was it left in its fragmentary state, but, like a number of other iconic pieces of classical sculpture, it was actually thought to define the very concept of beauty in art. This was almost entirely due to the writings of the great German scholar and cicerone residing in Rome, Johann Joachim Winckelmann (1717–1768). In his extraordinarily influential *History of the Art of Antiquity*, published in 1764, he raised awareness of the inherent beauty of antique sculpture. Of the *Torso* he wrote, 'Abused and mutilated in the extreme, deprived as it is of head, arms,

and legs, this statue still appears, to those capable of looking into the mysteries of art, in a blaze of its former beauty. In this Herakles, the artist has figured a high ideal of beauty raised above its nature, and a nature of virile maturity elevated to a state of divine contentment.'[4] Unlike some of his other publications, Winckelmann's *History* was not to be translated into English until the mid-nineteenth century; however, it was known to many British scholars and artists, generally through French or Italian translations. Sir Joshua Reynolds (1723–1792) spoke eloquently of the *Torso* in his Discourse on sculpture, delivered at the Royal Academy of Arts in London in 1780: 'what artist ever looked at the Torso without feeling a warmth of enthusiasm, as from the highest efforts of poetry? … What is there in this fragment that produces this effect, but the perfection of this science in abstract form?'[5] But it was not until after the Parthenon marbles had been brought to England by Lord Elgin in the first decade of the nineteenth century that doubts were to be expressed about the merits of restoring ancient sculpture more generally. The sculptor Joseph Nollekens (see nos. 15–18) was asked by the Select Committee of the House of Commons in 1816, set up to decide whether or not to recommend the acquisition of Lord Elgin's marbles for the nation: 'For the use of artists, will they [Lord Elgin's marbles] not answer every purpose in their present state?' The sculptor replied, 'Yes, perfectly; I would not have them touched.' Flaxman concurred.[6] The restoration of ancient sculpture was to be actively mocked just over a decade later: the sculptor and writer Allan Cunningham (an assistant of Francis Chantrey), wrote in 1831 of the 'patching up and repairing [of] old fragments for the collections of those rich and travelled persons whose pleasure it was to purchase them. In this kind of jugglery the Italians excel all mankind – they gather together the crushed and mutilated members of two or three old marbles, and by means of a little skill of hand, good cement, and sleight in colouring, raise up a complete figure, on which they confer the name of some lost statue, and as such sell it to those whose pockets are better furnished than their heads – especially our English *cognoscenti*.'[7]

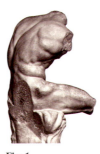

Fig. 1
The Belvedere Torso
Marble
Height 159 cm

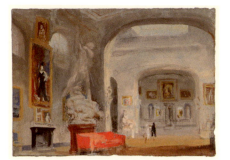

Fig. 2
J.M.W. Turner
The Sculpture Gallery at Petworth House
1827
Gouache and watercolour on paper
13.8 x 18.9 cm
Tate

Throughout the eighteenth century excavations in and around Rome, sometimes led by British residents in Italy, such as Gavin Hamilton, revealed more treasures. The passionate responses to ancient sculpture were carried over to contemporary works, often made in emulation of antique prototypes. Partly fired by Winckelmann's writings, the enthusiasm and fervour felt by collectors and connoisseurs for sculpture was palpable, and innumerable marble works were specially commissioned from artists living in Rome. The painter J.M.W. Turner wrote to Chantrey from Rome in 1828, 'Sculpture, of course, first, for it carries away all the patronage, so it is said, in Rome …'[8] From the 1760s onwards galleries specifically designed to display sculpture began to be built in English country houses (fig. 2). Some collectors, such as the Duke of Bedford at Woburn, displayed their antique and modern sculptures alongside each other, in the same sculpture gallery, implicitly evoking the connections between them, particularly representations of ideal human forms. Although copies of ancient works were made by Francis Harwood and Joseph Wilton among others, antique sculptures were above all exemplars, from which later sculptors could learn. It was hoped indeed that the Parthenon marbles, having been brought to London, would 'serve … as models and examples to those, who by knowing how to revere and appreciate them, may learn first to imitate, and ultimately to rival them.'[9]

Neoclassical sculpture as an international style
Rome was a centre of attraction not just for the British, but for a large international community of connoisseurs and artists. British patrons were attracted to many foreign sculptors, above all Canova (nos. 4 and 5), but also Thorvaldsen (nos. 23-25), and to a lesser extent the Swedish artist Sergel (no. 22), and later the American sculptor Hiram Powers (no. 20). The international quality of neoclassical art was fundamental, for the artists wished to promote a style which was 'of universal significance and eternal validity'.[10]

Winckelmann's definition of beauty, identified not only in the *Torso*, but in the *Apollo Belvedere*, and other canonic works, became the *beau idéal*, the standard by which subsequent works of art could be judged and appreciated. The term 'neoclassical' was originally a pejorative adjective, coined in the mid-nineteenth century, when the style was seen as a debased and frigid version of classical Greek and Roman art.[11] In fact, the works of art made during what is now called the neoclassical period[12] aimed to express the moral purity and virtue seen in ancient art, which was perceived as infinitely superior to the excesses of the rococo style, and to the baroque forms and realistic surface textures of Bernini's sculptures.[13] In his Discourse on Sculpture of 1780 Joshua Reynolds called attention to the 'intellectual pleasure' of sculpture, which was 'incompatible with what is merely addressed to the senses'.[14] Other British commentators and sculptors in the late eighteenth and early nineteenth century, such as Flaxman, stressed the emergence of contemporary sculpture from its previous 'state of barbarity'.[15] Because of its moral superiority, sculpture could wholly absorb and elevate the viewer; Winckelmann spoke of 'forget[ting]' all else' when he looked at a masterpiece of sculpture,

and continued, 'I myself adopt an elevated stance, in order to be worthy of gazing upon it.'[16]

The works displayed here were all originally owned, and often commissioned, by British patrons, reflecting the enormous impact visitors to Italy from Britain had on sculpture at this date. British artists visiting Rome were inevitably inspired to a great extent by Italian artists working there: Nollekens worked alongside Cavaceppi in the 1760s, while Gibson and Wyatt both spent time in Canova's studio, shortly before the master died in 1822. But the young Canova himself was almost certainly influenced by Gavin Hamilton's views on antiquity, after having met the Scottish artist in Rome in 1780. Canova scorned copying antique sculptures, but believed it was essential to study them.[17] This was a very different attitude from the practice of artists of the previous generation, and indicated the way other sculptors were developing by the late eighteenth century: Banks and later Flaxman also imitated and studied, rather than copied, antique models, relishing the practice of drawing from nature as well as revering ancient marbles. British artists and patrons were indeed arguably fundamental catalysts for the development of neoclassical sculpture, and its intimate intertwining of naturalism and idealism. Canova's meeting with Hamilton was decisive in the evolution of his art, and transformed him from being effectively a late-rococo artist, working in a mode such as he had practised in Venice, into a vigorous practitioner of the neoclassical style, which was to be admired and adulated throughout Europe.

Working practices
All the exhibits here are of marble, but depend from preparatory drawings and models (often now sadly lost), which were fundamental to the genesis of the finished piece. Usually the sculptor would make a first sketch of the figure or composition on paper, which he would then translate into a small clay model. A more developed and larger clay model, sometimes supported on a metal armature, would then be made, based on the initial clay *bozzetto*. Clay's malleability means that it can be easily modelled, and adjustments can be made if necessary. If the sculptor (and, if it was a commission, the patron) was satisfied with this more finished clay sketch model, a plaster mould would be made of it, and this mould in turn used to cast a full-size plaster model. This plaster would be virtually identical to the clay version from which it had been cast, though it was more practical for use in the studio, since plaster is more durable and less vulnerable than unfired clay. On occasion the clay models would be subsequently fired, and these terracottas kept and prized as the artist's original models, vivid records of his working methods.[18] However, the plaster models were vital for the next stage in the process of carving the marble block. In order to translate the forms into stone, the surface of the plaster was dotted with raised points, which would be marked in a similar configuration onto the surface of the marble block, giving the sculptor and his assistants tracking points from which to work. A pointing mechanism would be used for this process; this was a device whereby the points could be

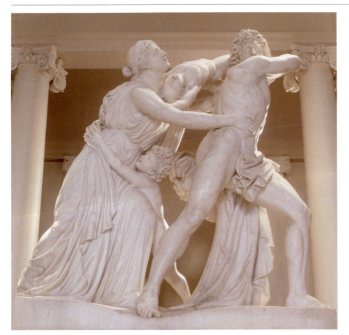

transferred from the plaster to the marble. Often the initial roughing out of the marble would be carried out by assistants, although usually the sculptor himself finished the piece and executed the final touches to the surface. Most of the sculptures here are nudes, and Cunningham noted that even if the final figure was to be clothed it was initially modelled naked, and then drapery added, in order to ensure 'accuracy of proportion and gracefulness of shape'.[19] Once carved, some marble sculptures were given a surface finish to dull down the bright whiteness of the marble – Canova apparently used diluted coffee. However, the sculptures in the present show do not have such surface treatments altering the colour of the stone, because this was not always felt to be desirable; the Duke of Bedford for example specifically asked Canova not to add surface colour to his version of *The Three Graces*.

Collectors visited artists' studios, watching them at work, and seeing creations which they were tempted to buy. *The Three Graces* (no. 5) was commissioned as a result of such a visit by the Duke of Bedford to Canova's workshop in 1814. Gibson's *Hylas surprised by the Naiads* was likewise ordered after William Haldimand saw the sculptor at work on the model in 1826, though evidently the enthusiasm of the moment passed, and he later cancelled his commission (see no. 10).

The display and viewing of sculpture
The acquisition of sculpture was intimately bound up with the question of display. A number of patrons and collectors, such as the 6th Duke of Devonshire at Chatsworth, or the 3rd Earl of Egremont

at Petworth, constructed galleries specifically for their sculpture collections (fig. 2). Conversely a few, such as Thomas Mansel Talbot, paradoxically spent considerable sums on acquiring sculpture, much of which was left in packing cases, and never in the event displayed (no. 22). Marble sculptures were often large and heavy, and at this date marble, rather than any other material, was demanded by British patrons. The sculptures therefore needed adequate display space, and for this reason country houses, rather than town houses in London, were generally the preferred locations. Indeed from the 1730s onwards aristocratic art collections began more and more to be housed outside the metropolis, sometimes because the owner, such as Lord Cobham at Stowe, had retired to the country for political reasons. [20] The majority of the works in the exhibition were first seen in country seats. Likewise, Flaxman's gigantic *Fury of Athamas*, made for the Earl Bishop of Derry in the early 1790s, was later displayed (after a series of adventures) at the earl's seat, Ickworth in Suffolk, where it dominated the entrance hall (fig. 3). Although the sculpture galleries or interiors were usually luminous spaces pervaded by daylight, marbles were on occasion viewed by candlelight, rather than natural light, giving the figures and reliefs a dramatic and evocative presence. The painter Benjamin Robert Haydon (1786-1846) made studies of the Parthenon marbles by candlelight when they were on display at Burlington House. He recorded verbally, as well as through his drawings, this awe-inspiring experience: 'As the light streamed across the room and died away into obscurity, there was something solemn and awful in the grand forms and heads and trunks and fragments of mighty temples and columns that lay scattered about in sublime insensibility…'[21] Although in this instance Haydon was studying ancient sculpture, visitors often favoured looking at contemporary, and indeed medieval sculpture by artificial light, in order to enjoy the sharp contrasts of light and shade on the sculpted forms so that they appeared both more striking and even life-like.

The display in this exhibition of these dramatic and yet serene marble sculptures aims to convey some of the exhilaration felt by their creators and owners. The spaces in which they are placed, the Duveen Galleries at Tate Britain, echo some of the grander country house sculpture galleries of the neoclassical period, and it is in this more modern, public context that viewers will be stirred both by the grave nobility and the startling immediacy of these extraordinary works.

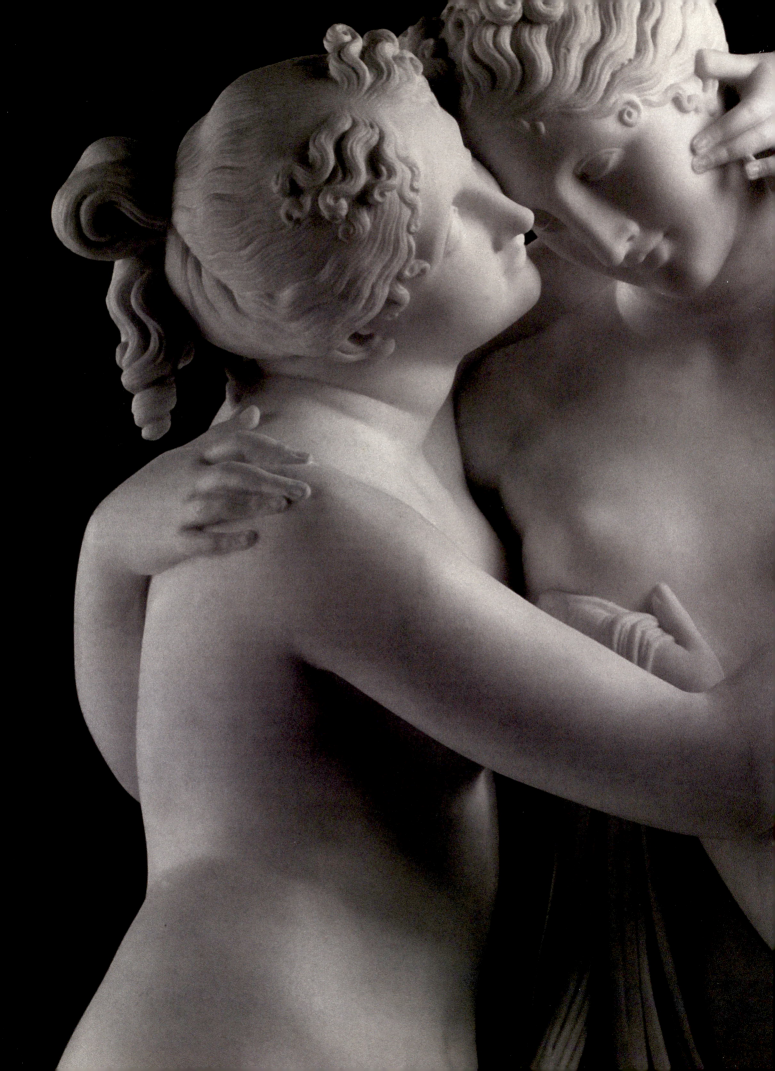

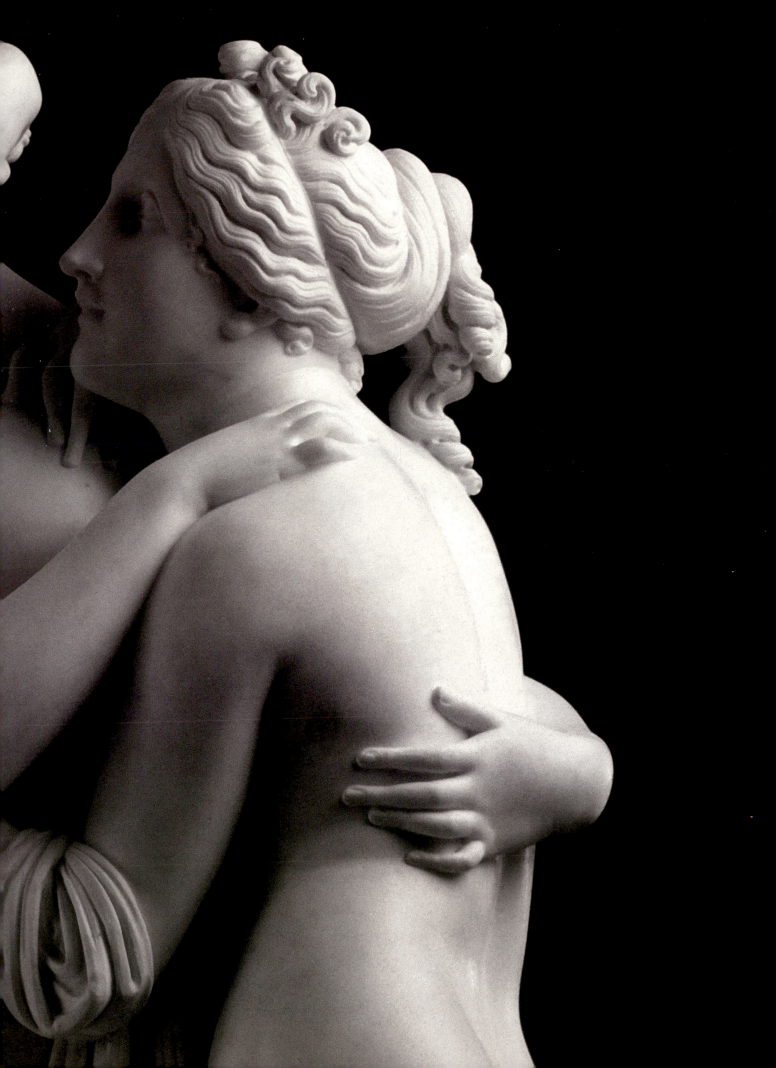

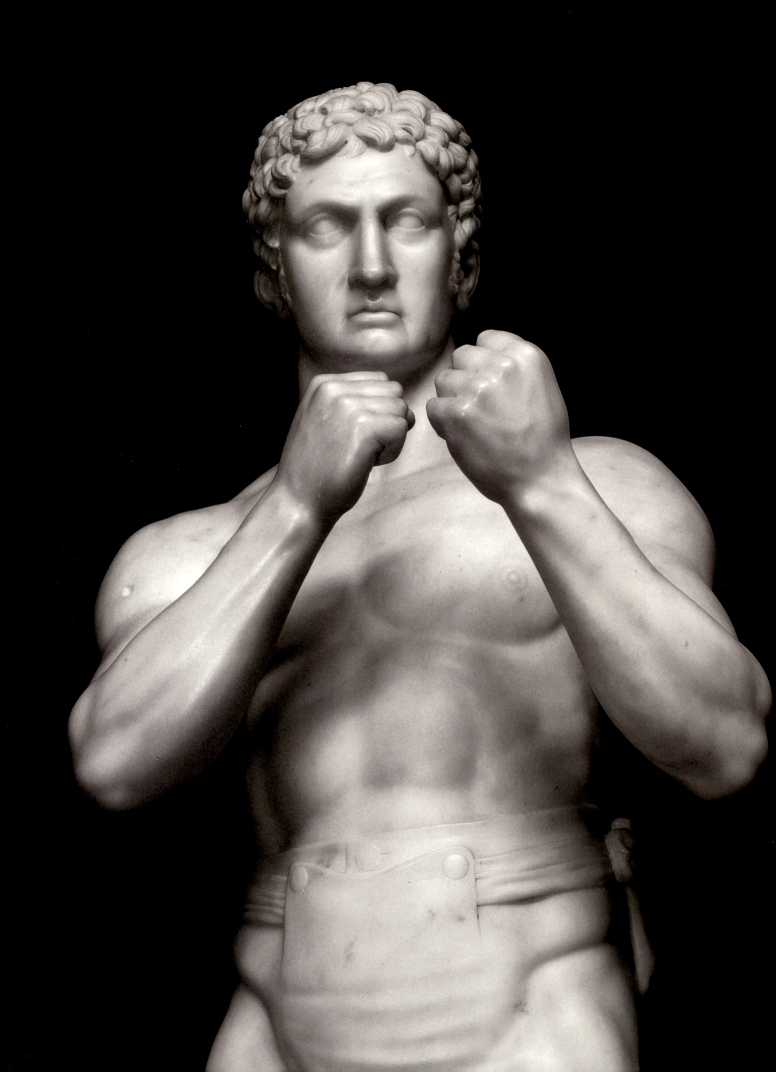

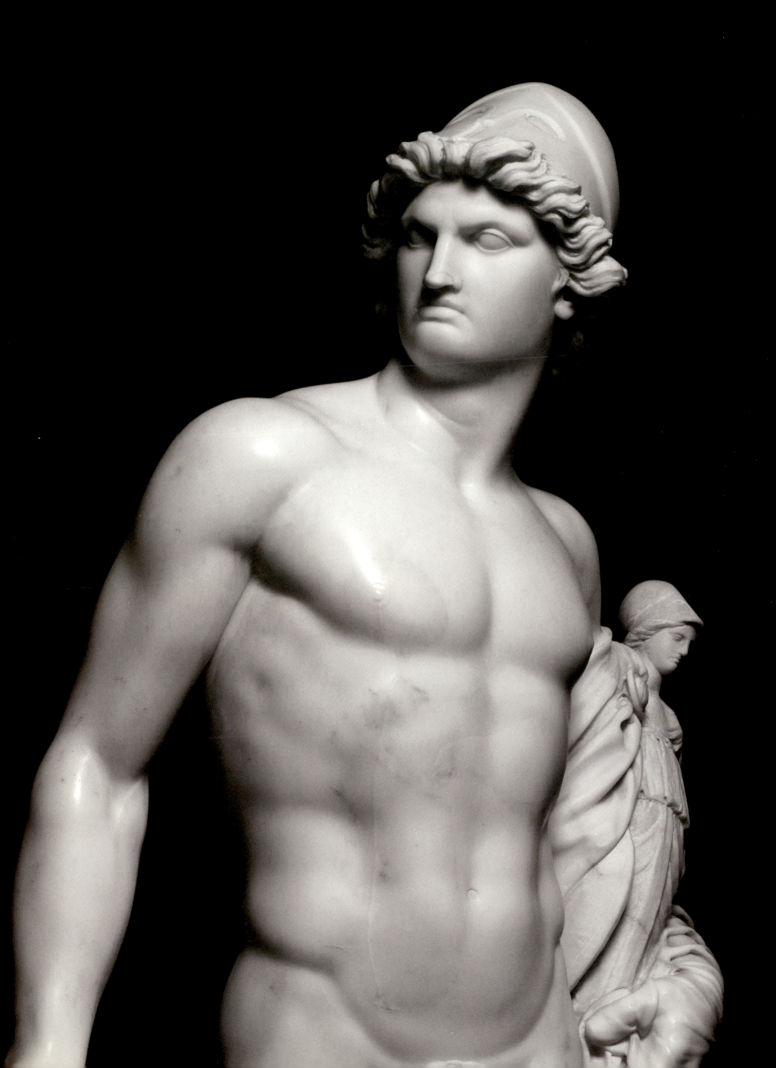

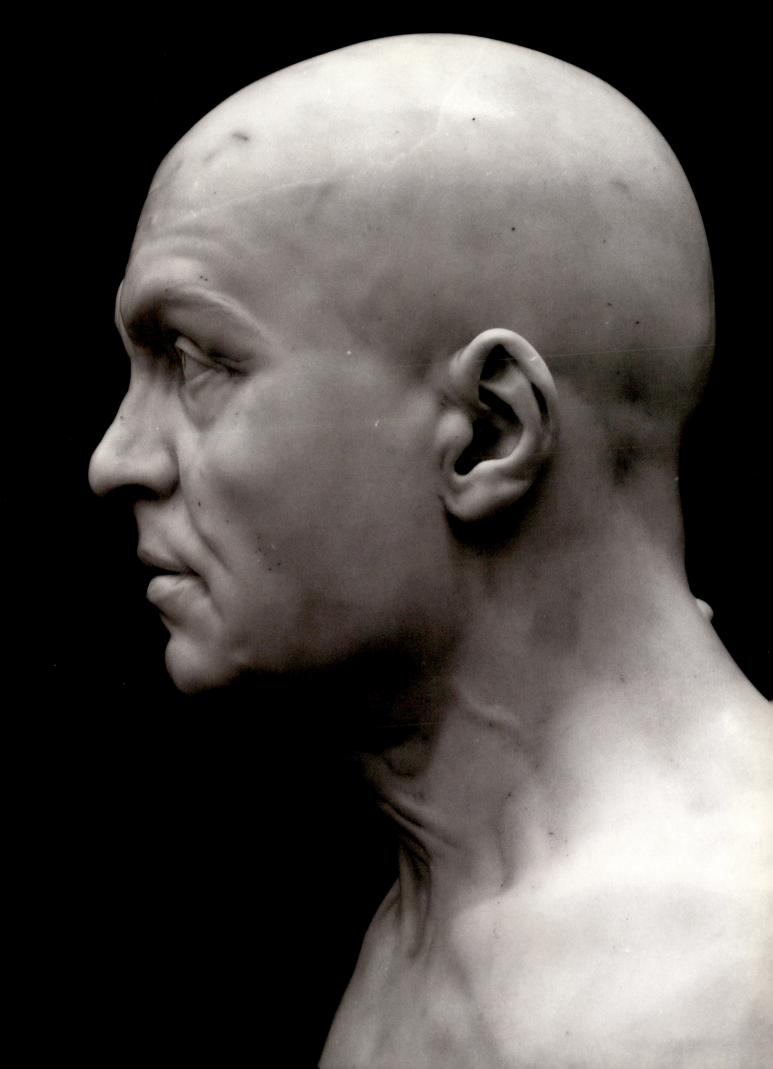

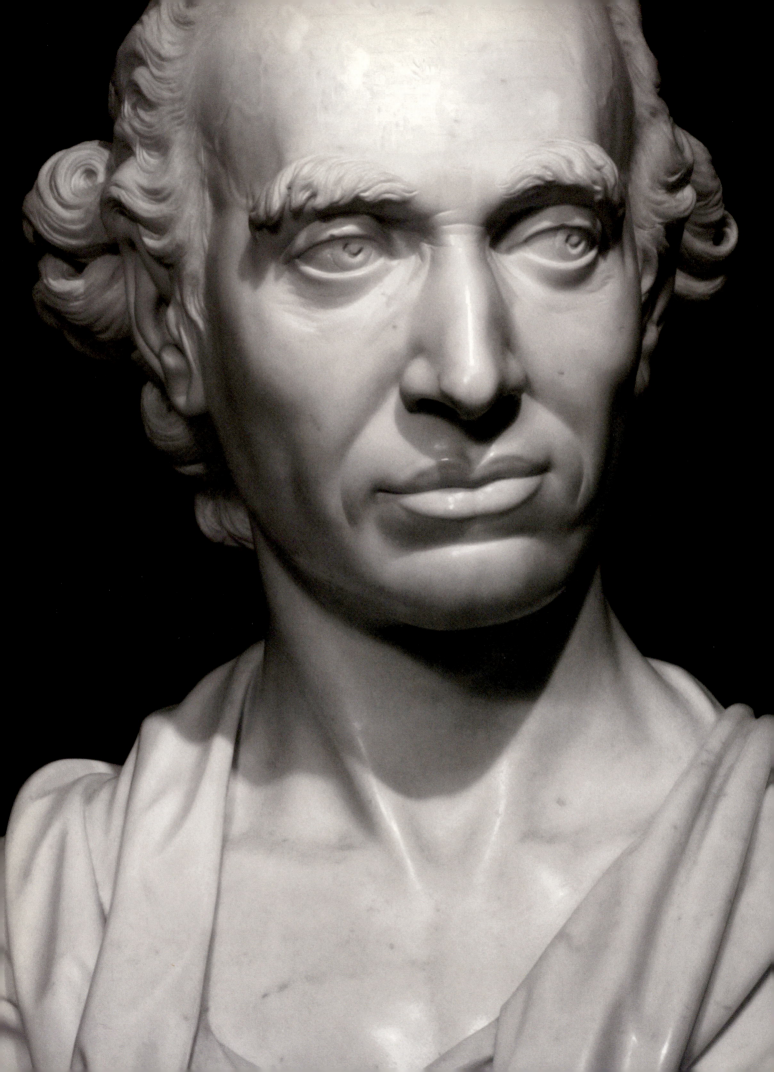

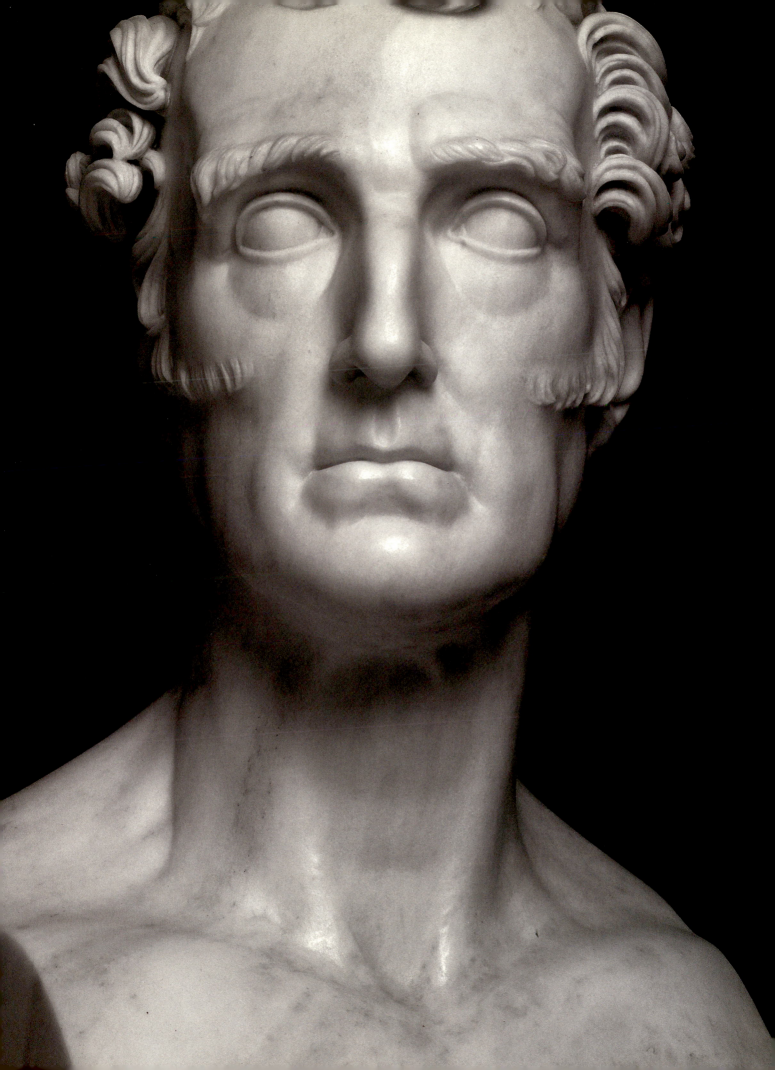

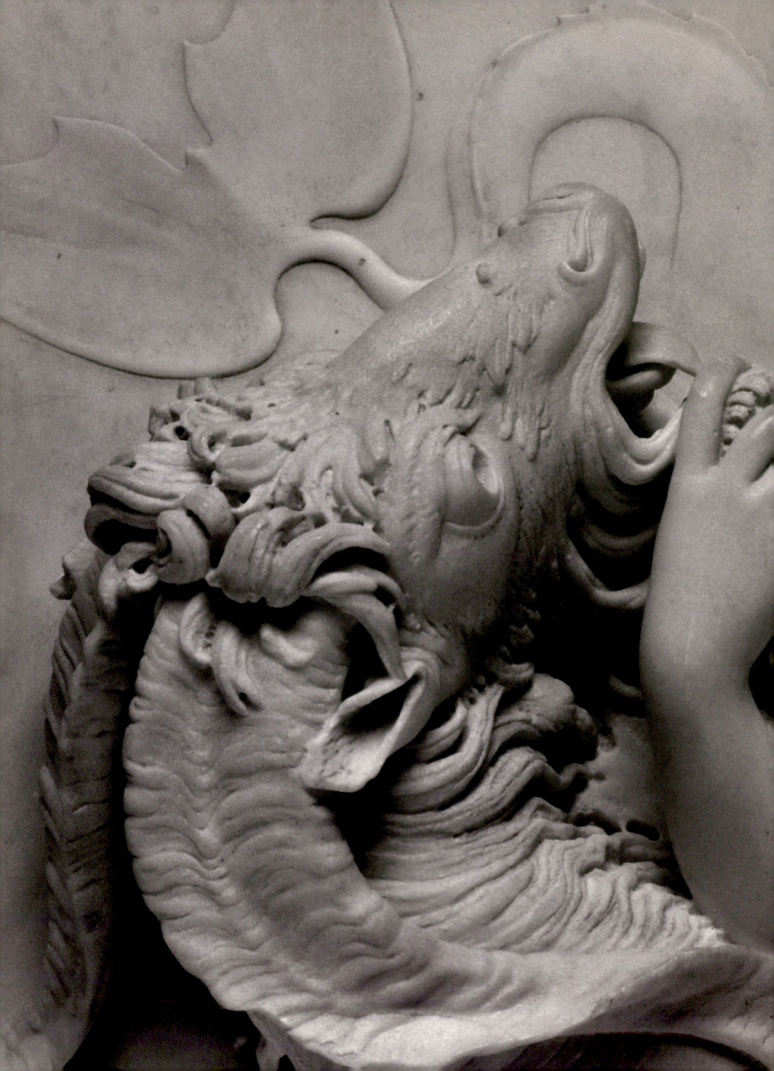

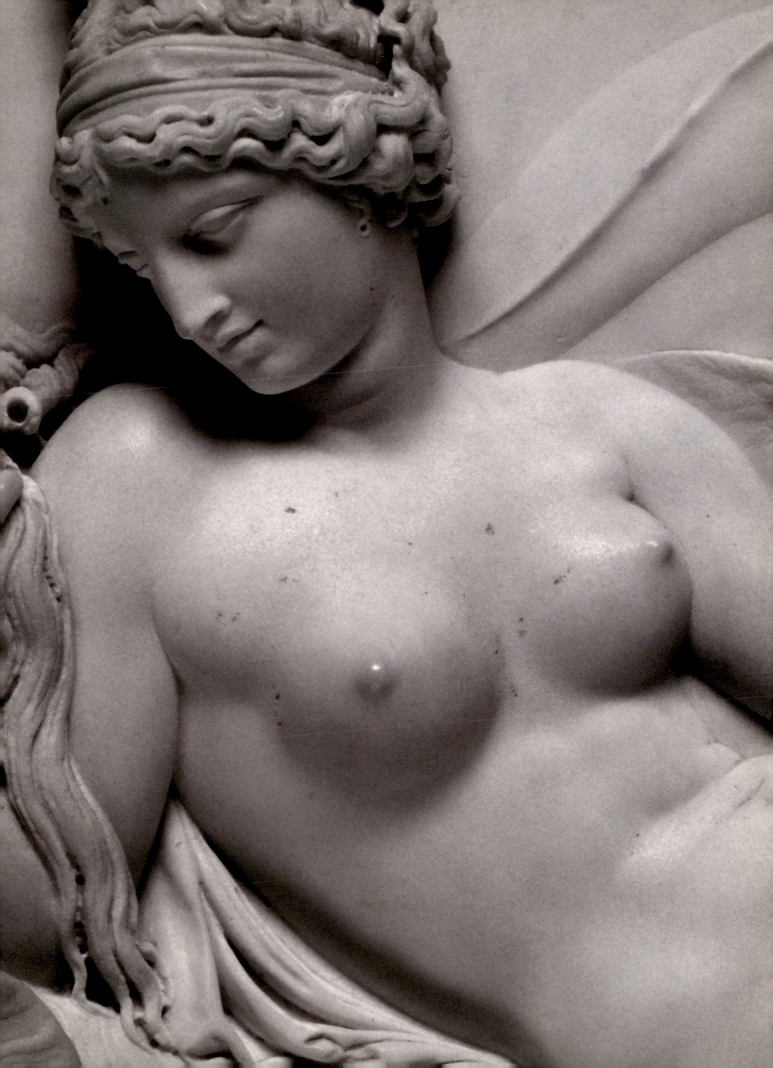

John Bacon the Younger (1777–1859)
Richard Payne Knight (1751–1824)
Signed and dated 1814, Marble and bronze, Ht. without socle 57.2 cm; ht. with socle 69 cm, The National Portrait Gallery, London, inv. no. 4887

Provenance Christopher Gibbs Ltd, London, 1971; Cyril Humphris, London, 1972, from whom purchased by the National Portrait Gallery.
Literature *European Magazine*, 1 August 1844 (stipple engraving by Thomson); Clarke and Penny 1982, cat. 65 on p. 144; *George Bullock: Cabinet-Maker*, pp.144–5, cat. 71; Saywell and Simon 2004, p. 357.
Exhibited *The Arrogant Connoisseur: Richard Payne Knight 1751–1824*, Whitworth Art Gallery, Manchester, 1982; *George Bullock: Cabinet-Maker*, Blairman and Sons, London, February–March 1988, (cat. 71).

Richard Payne Knight was a renowned scholar and collector, and made 'the Tours of France and Italy', including Sicily, in the 1770s. In 1781 he became a member of the Society of Dilettanti, a dining club for gentlemen who had travelled to Italy. He published a number of scholarly books on ancient art, including the notorious *Discourse on the Worship of Priapus* with William Hamilton in 1786. In 1814 he was appointed a Trustee of the British Museum, representing the Townley family; he had helped negotiate the acquisition of the Townley marbles for the Museum following Townley's death. In the same year he made the decision to bequeath to the British Museum his own important collection of ancient coins, bronzes, curiosities and marbles.

John Bacon the Younger was trained by his father, the sculptor John Bacon (1740–1799), and specialised in portrait busts and monuments. The bronze drapery on the present bust may have been executed by the cabinet-maker and sculptor George Bullock (1778/82–1818), and this version was possibly executed for the Marquess of Abercorn, although as its provenance is unknown prior to 1971, this remains uncertain. An earlier version of this portrait, in marble, but without the bronze drapery, dated 1812, is in the British Museum, and may have been acquired around the time of Knight's bequest. Knight knew and supported Bacon through his membership of the Committee of Taste, a group of collectors and connoisseurs that had been established to select sculptors for monuments to patriotic heroes in St Paul's Cathedral (Clarke and Penny 1982, citing Farington's *Diary*, 14 June 1810, X, p. 3669).

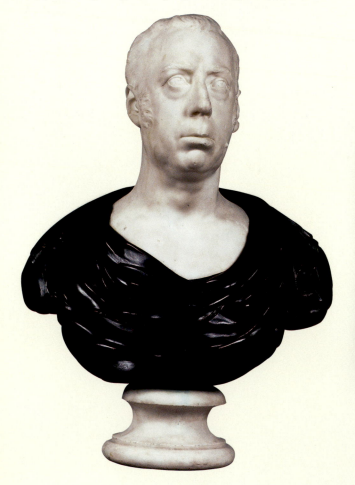

Thomas Banks (1735–1805)
The Falling Titan
Signed and dated 1786, Marble, 84.5 x 90.2 cm,
The Royal Academy of Arts, London, inv. no. 03/1673

Provenance Presented by the artist to the Royal Academy as his Diploma piece in 1786.
Literature Irwin 1966, p. 57 and pl. 62; Radcliffe 1969, p. 48 and fig. 8 on p. 47; Bryant *Soane* 2005, pp. 33–4 (with earlier literature); Bryant *Journal* 2005, p. 53; Roscoe 2009 (forthcoming).
Exhibited Manchester, *Art Treasures Exhibition*, 1857 (cat. 72); London, International Exhibition, 1862; Royal Academy of Arts, London, 1873 (cat. 268); Royal Academy of Arts, London, 1939 (cat. 213); *Italian Art and Britain*, Royal Academy of Arts, London, 1960 (cat. 247); *Treasures from the Royal Academy: an Exhibition of Paintings, Drawings, Sculpture and other Possessions earlier than about 1850*, Royal Academy of Arts, London, 1963, (cat. 27); *Royal Academy of Arts Bicentenary exhibition 1768–1968*, Royal Academy of Arts, London, 1968 (cat. 134); Royal Academy of Arts, London, 1982 (cat. 49); Tate Britain, 2000–4; *Thomas Banks, 1735–1805: Britain's First Modern Sculptor*, Sir John Soane's Museum 2005 (cat. 23); *Gothic Nightmares: Fuseli, Blake and the Romantic Imagination*, Tate Britain 2006 (cat. 21); *Art at the Rockface: The Fascination of Stone*, Norwich Castle Museum and Art Gallery, and Millennium Galleries, Sheffield, 2006–7.

This was Banks's Diploma piece, presented to the Royal Academy on the occasion of his election as a Royal Academician in 1786. In 1828 J.T. Smith described it as 'a work far superior to any before produced in England, and which, perhaps, never will be surpassed'. In true academic fashion Banks has superbly conveyed the anatomy of the twisted figure of the male nude, complete with the dramatic illusionism of the boulders tumbling on top of him. Tiny figures carved into the rocks give a sense of scale to the giant. The sculpture's size recalls French *morceaux de réception* presented by recently elected members of the French Académie, just as members of the Royal Academy presented their diploma works on the occasion of their election, as seen here. The French *morceaux* were generally marbles of about half life-size, which nevertheless retained a degree of monumentality. The story illustrated here is probably from the post-Homeric legend concerning the giants who were rebel sons of Heaven and Earth. After piling up mountains to reach Olympus they were defeated by Heracles, and crushed beneath falling mountains and volcanoes (see Bryant 2005, p. 34). Banks's undated etching of the subject may be after a lost sketch which itself led to the creation of the sculpture (*ibid.*, p. 33, cat. 22). The fine draughtsmanship in the etching recalls Banks's friend Fuseli's dramatic renderings of the human figure. Banks had spent seven years in Rome from 1772 onwards, and this work epitomises his command of classical forms and subjects.

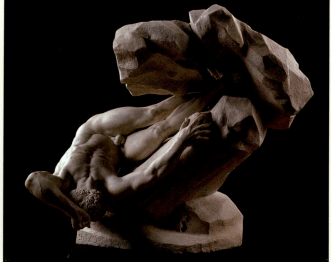

Thomas Banks (1735–1805)
Thetis dipping Achilles into the Styx
*c.*1786, Marble, 88 x 98 cm, Victoria and Albert Museum, London,
inv. no. A.101.1–1937

Provenance Commissioned by Colonel Thomas Johnes (1748–1816) of Hafod, Cardiganshire; recorded in the Conservatory at Hafod in 1803; Clumber House, Nottinghamshire, residence of the Duke of Newcastle by 1845; Clumber House Sale, Christie, Manson and Woods, London, 21 October 1937, lot 337; purchased at the sale by Cecil Keitch and Kerin, who acted as agents for the Museum.
Literature Bilbey and Trusted 2002, pp. 49–50; Bryant 2005, pp. 35–6 (with earlier literature); Roscoe 2009 (forthcoming).
Exhibited Royal Academy of Arts, London, 1790 (no. 658); *Royal Academy of Arts Bicentenary Exhibition 1768–1968*, Royal Academy of Arts, London, 1968–9 (cat. 132); *Thomas Banks* 2005 (cat. 26).

This under-lifesize sculpture originally adorned Thomas Johnes's large domed octagonal Conservatory, which adjoined the library in his house. The head of Thetis is a portrait of his second wife, Jane, and the head of the infant Achilles their infant daughter Mariamne. Achilles's mother Thetis dipped him at birth in the waters of the river Styx to make him invulnerable, but held him by the heel, where he was to be eventually mortally wounded. A rendering of classical myth is here combined with contemporary portraits of the sitter's wife and child, the semi-nude figure echoing antique statuary, while the pose and curves of the body bending forward, and flowing drapery, have an immediate and sensuous appeal. This was not a contradiction: Banks was considered a 'modern' sculptor by his contemporaries (Bryant 2005, p. 7), and at the same time he was singled out by Joshua Reynolds as 'the first British sculptor who had produced works of classic grace'. Reynolds felt sure that 'his mind was ever dwelling on subjects worthy of an ancient Greek.'

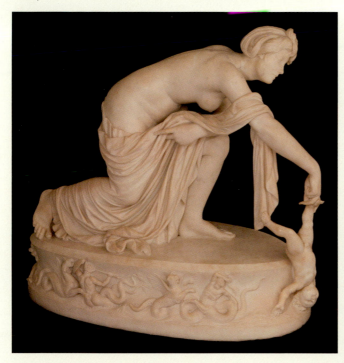

Antonio Canova (1757–1822)
Psyche
*c.*1789–93, Marble, 152 x 50 x 45 cm
Private Collection

Provenance Bought from the sculptor by Henry Blundell and installed at Ince Blundell Hall, Lancashire. By descent to the present owner.
Literature *The Age of Neo-Classicism* 1972, cat. 314, pp. 202–3 (with earlier literature); Honour and Weston-Lewis 1995 (with earlier literature), cat. 20, p. 91.
Exhibited *The Age of Neo-Classicism* 1972, cat. 314; *The Three Graces. Antonio Canova*, National Gallery of Scotland, Edinburgh, 1995, cat. 20.

According to Apuleius's *Golden Ass*, written in the second century CE, Cupid fell in love with the beautiful nymph Psyche, but forbade her to look at him, and visited her only after dark. One night she took a lamp and gazed on him as he slept, but accidentally awoke him by letting a drop of hot oil fall on his body. He left her angrily, and she wandered the earth trying to find him again. Eventually Jupiter carried her up to heaven where she was reunited with Cupid. Neoplatonic thinkers interpreted Psyche as an allegory of the Soul seeking Desire (Cupid). She is often, as here, represented with a butterfly, a symbol of the Soul.

Henry Blundell may have first commissioned this work from Canova through his agent in Rome – John Thorpe – in 1789, although it was evidently not completed until 1792. Canova was paid 600 *zecchini*, and Blundell additionally gave him drawing instruments and 'other things' worth a further 100 *zecchini*. It was housed at Ince Blundell Hall in Lancashire, among Blundell's collection of mostly ancient sculpture. Canova carved a second version in 1793–4 for Girolamo Zulian, formerly Venetian ambassador to Rome; this figure is now in the Kunsthalle, Bremen. The graceful pose and sensitive rendering of the female nude seen here prefigure Canova's later *Three Graces* (no. 5).

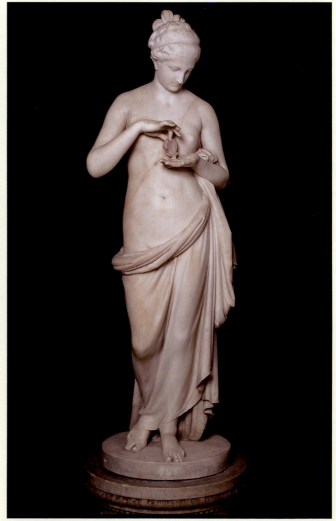

Antonio Canova (1757–1822)
The Three Graces
1815–17, Marble, 173 x 97.2 x 75 cm, National Galleries of Scotland, Edinburgh
and The Victoria and Albert Museum, London (purchased with the assistance of
The National Heritage Memorial Fund, The Art Fund, J. Paul Getty II, Baron
Heinrich Thyssen-Bornemisza and Public Donations, 1994)
inv. no 2626/A.4-1994

Provenance Commissioned by John Russell, 6th Duke of Bedford for the
Temple of the Graces, Woburn Abbey 1815, completed 1817; purchased jointly
by the Victoria and Albert Museum and the National Galleries of Scotland 1994
with the aid of major contributions from the National Heritage Memorial Fund,
the Art Fund, John Paul Getty II, Baron Hans Heinrich Thyssen-Bornemisza,
and public donations.
Literature *The Age of Neo-Classicism* 1972, (cat. 322), pp. 207–8 (with earlier
literature); Salling 1972, pp. 215, 216, and fig. 1 on p. 214; Honour and Weston-
Lewis 1995 (with earlier literature); Baker 2000, pp. 159–68; Potts 2000, pp.
4951; Yarrington 2002, pp. 30–43; Roscoe 2009 (forthcoming).
Exhibited *The Age of Neo-Classicism* 1972 (cat. 322); *The Treasure Houses of Britain*
1985, (cat. 480); *The Three Graces. Antonio Canova*, National Gallery of Scotland,
Edinburgh, 1995, (cat. 12); *The Triumph of Venus. The Image of Woman in
Eighteenth-Century Venetian Painting*, Thyssen-Bornemisza Collection, Madrid,
1997–8.

Canova first received a commission for a group of the Three Graces from
Josephine de Beauharnais, the divorced wife of Napoleon, in 1812, although she
died in May 1814, before it was completed. When the 6th Duke of Bedford
visited the sculptor's studio in Rome in December 1814 he saw the model for this
piece, and wanted to acquire the finished marble. However, Josephine's son
Prince Eugène de Beauharnais also wished to buy the group first commissioned
by his mother, and Canova therefore offered to make the Duke a second version,
a 'replica with alterations'. The Duke gladly accepted, and wrote to Canova on 21
January 1815, 'I frankly declare that I have seen nothing in ancient or modern
sculpture that has given me more pleasure … I leave the variations in the group
… entirely to your judgement, but I hope that *the true grace* that so particularly
distinguishes this work will be completely preserved.' The sculpture was
delivered to Woburn in 1817, and probably cost 6000 *zecchini* (£3000). The
version bought by Josephine's son is now in the Hermitage, St Petersburg. The
supporting rectangular altar in the Hermitage version was replaced in the
Woburn group by a round column, less obtrusive and more in keeping with the
round contours of the bodies of the Graces. The marble used for the Duke of
Bedford's group is also of higher quality, with no disfiguring veins. Canova
himself evidently preferred the second version, and this was the one he

ultimately chose to have represented in engravings of his work.

The idea of the Three Graces derives from ancient Greek literature. Hesiod
called them the daughters of Jupiter, embodying different aspects of grace.
Thalia, the eldest of the sisters (shown by Canova in the centre), was associated
with Youth and Beauty; Euphrosyne (on the left) added zest to 'festive board and
social enjoyments', while Aglaia, the youngest (on the right), was the consort of
Vulcan, the artist-god, and enhanced his works with elegance and grace. These
names are inscribed on some of the prints of Canova's group. As Hugh Honour
has noted, there was a superabundance of visual sources for the subject: the
Three Graces were represented in ancient Roman sculpture, such as the group in
the Vatican, and another in the Piccolomini Library in Siena Cathedral. They also
appear on Italian renaissance medals, while Germain Pilon had carved a variation
of them (fully clothed) for the monument to the heart of Henri II of 1559–63,
which by the early nineteenth century was in Lenoir's Musée des Monuments
Français in Paris. Canova himself had painted versions of the subject from the
1790s onwards.

One of the most famous European sculptures from the time it was made,
Canova's group was enthusiastically celebrated by its original owner, the 6th
Duke of Bedford, who in his *Outline Engravings* of 1822 called it 'a work of
consummate skill; certainly unsurpassed by any modern specimen of the art of
sculpture', and who noted 'the *morbidezza*, – that look of living softness given to
the surface of the marble, which appears as if it would yield to the touch'.
Canova's friend and admirer Quatremère de Quincy wrote that the sculptor
wanted to show the conception of grace through 'the novel and ingenious
entwining of three female figures which, from whatever side they are seen as one
walks round them, reveal, in different configurations, nuanced varieties of forms,
of contours and of human affections and sympathy.'

Now widely recognized as one of the greatest European artists of his day,
Canova's reputation sank from the mid-nineteenth century onwards, partly
because of what was seen as the problematic relation of his work to ancient
sculpture. The great German scholar Gustav Waagen commented dourly on *The
Three Graces* in his extensive survey of works of art in British collections of 1854:
'But however attractive the tender and masterly finish of the dazzling white
marble, the pretty but insipid character of the heads cannot gratify a taste familiar
with the antique.'

In 1819 Canova's sculpture was displayed in the top-lit Temple of the Graces
at Woburn, a rotunda specially built for it by Wyatt (later Sir Jeffrey Wyatville) at
the west end of the Sculpture Gallery. On his visit to Woburn in 1815, before the
Temple was built, the sculptor himself had apparently advised on its position and
lighting. The group was set on what was thought to be an ancient marble plinth
(in fact dating from the eighteenth century), which was fitted with bearings,
while the base of the sculpture was given brass knobs, so that it could be rotated,
and its multiple viewpoints enjoyed as it was turned. It was seen in the context of
the outstanding collection of ancient sculpture in the Duke's collection, as well as
works by contemporary British sculptors, notably Joseph Nollekens, Francis
Chantrey (see no. 6), and Richard Westmacott.

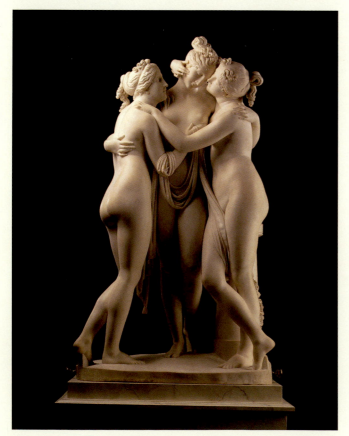

Francis Chantrey (1781–1841)
Lady Louisa Russell as a Child (1813–1905)
1817–18, Marble, 117 x 29 x 32 cm.
By kind permission of His Grace the Duke of Bedford and the Trustees of the
Bedford Estates, inv. no 5245

Provenance Commissioned from the artist by John Russell,
6th Duke of Bedford.
Literature *Outline Engravings* 1822, unpaginated; Waagen 1854, III, p. 472,
Letter XXXIII; Honour and Weston-Lewis 1995, fig. 61 on p. 66, and pp. 68–9;
Yarrington 2000, p. 135; *idem* 2002; Roscoe 2009(forthcoming).
Exhibited Royal Academy of Arts, London, 1818, (no. 1116).

This figure was commissioned by the 6th Duke of Bedford to form a pair with
the statue of his daughter Georgiana by Thorvaldsen (see also the entry for no.
23). Chantrey's clothed and animated figure epitomises the sentimental style
which appealed to British audiences, and contrasts with the more severely
Grecian figure by the Danish artist. Lady Louisa was also four years old when
her portrait was sculpted. Both figures were installed in niches in the vestibule of
the Temple of the Graces. In his *Outline Engravings* the Duke described his
second daughter depicted here 'at the moment she has taken up her favourite
dove, and is pressing it to her bosom'. He added that it had a 'natural and
pleasing expression', typical of Chantrey's statues of children. However,
Waagen, writing a generation later in 1854, commented acerbically that the
figure 'has a most studied and affected expression. The drapery, which is drawn
up, is treated in the manner peculiar to this artist, which, though popular in
England, is devoid of style.'

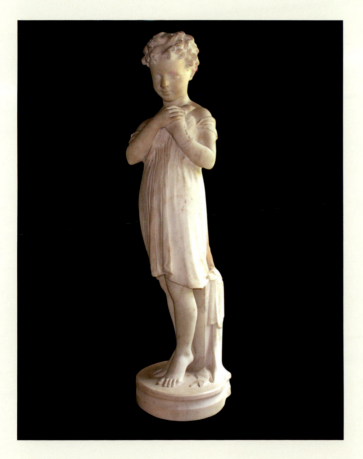

John Deare (1759–1798)
Venus Reclining on a Sea Monster with Cupid and a Putto
1785-87, Marble, 33.7 x 58.4 cm, The J. Paul Getty Museum, Los Angeles, inv.
no. 98.SA.4

Provenance Probably commissioned by Sir Richard Worsley Bt. (1751–1805)
some time after 1788 for his house, Appuldercombe, on the Isle of Wight;
purchased by the J. Paul Getty Museum in 1988.
Literature Ingamells 1997, p. 1019; Fogelman and Fusco 1998, p. 104 (cat. 38);
Fogelman, Fusco and Stock 2000, pp. 94–6, pl. VII, figs. 17 and 18 on p. 112, and
illustrated on the cover (with earlier literature); *Oxford Dictionary of National
Biography* 2004, Vol. 15, p. 650.
Exhibited *Rome on the Grand Tour*, J. Paul Getty Museum, Los Angeles, 2002.

Deare, a native of Liverpool, carved this relief in Rome, where he lived from
1785 onwards, having won a travelling scholarship from the Royal Academy.
The unusual subject, the naked figure of Venus reclining languidly on the back of
a sea-goat amid foamy waves, the whole redolent of sexual tension, is derived
partly from an ancient Roman relief showing the wedding procession of
Poseidon and Amphitrite, now in the Glyptothek Munich, and an antique
Roman sarcophagus, now in the Louvre. Both works were in Rome when Deare
composed this piece. He made several versions, the first for Sir Cecil Bisshop at
Parham Park in Sussex, commissioned in 1787, and delivered some time after
September 1788 (this is still at Parham). Another marble version, one plaster and
two bronze versions are also known. The high quality of the present work
suggest that this is the one produced for Sir Richard Worsley Bt, which was
eulogised at the time; Deare had made a large marble relief of the *Judgement of
Jupiter* for Worsley shortly before (now in the Los Angeles County Museum of
Art). Deare's exquisite marbles were greatly admired by his contemporaries. In
1825 Henry Smithers cited Deare's friend George Cumberland's comments on
the present work: 'Worsley's … *Marine Venus* … show[s] a hand that … has
often been, even among artists, taken for an antique.' (Smithers 1825, p. 405;
quoted in Fogelman, Fusco and Stock). A pen and ink drawing by Deare now in
the Sackler Collection is close to the finished composition, and must be a
preliminary study for it (Fogelman, Fusco and Stock, fig. 23 on p. 114). Deare
specialised in reliefs of mythological subjects, often for interior decorative
schemes. This is a virtuoso piece, with its flowing elongated forms, and richly
textured surface, seen particularly in the movement of the water, and the hide of
the rough hairy goat, partly achieved through the use of a drill. Although the
sculptor made plentiful use of antique sources, he created a work reminiscent of
the Italian or French renaissance. Cumberland wrote that he 'took great delight
in these sportive subjects, and ultimately exhibited all his studies on that head in
a most finished basso-relievo, now in the family of Sir Richard Worsley.'
(Cumberland 1829, p. 48; cited in Fogelman, Fusco and Stock).

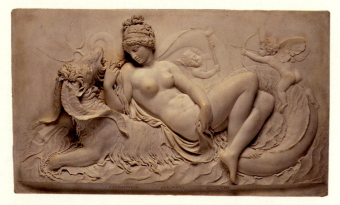

John Flaxman (1755–1826)
Apollo and Marpessa
*c.*1790–94, Marble, 48.4 x 54.8 cm
The Royal Academy of Arts, London, inv. no 03/1716

Provenance Presented by the artist to the Royal Academy as his Diploma
piece in 1800.
Literature Irwin 1966, pp. 64, 109, and pl. 77; Radcliffe 1969, p. 48 and fig. 9 on
p. 47; Irwin 1980, pp. 169–70, and fig. 233 on p. 170; Bindman 1979, p. 101, cat.
114; Roscoe 2009 (forthcoming)
Exhibited Royal Academy of Arts, London, 1800 (cat. 1004); *Art Treasures
Exhibition* Manchester, 1857, (cat. 76); *Old Masters … with works of deceased
masters of the British School*, Royal Academy of Arts, London, 1873 (cat. 257);
Diploma Gallery, Royal Academy of Arts, London, 1939 (cat. 246); *English Taste
in the 18th Century from Baroque to Neo-Classic*, Royal Academy of Arts, London,
1955 (cat. 407); *Italian Art and Britain*, Royal Academy of Arts, London, 1960
(cat. 236); *Treasures from the Royal Academy: an exhibition of paintings, drawings,
sculpture and other possessions earlier than about 1850*, Royal Academy of Arts,
London, 1963, (cat. 53); *John Flaxman, Mythology and Industry*, Hamburg and
Copenhagen, 1979, and Royal Academy of Arts, London, 1979 (cat. 114); *From
Reynolds to Lawrence: The First Sixty Years of the Royal Academy of Arts and its
Collections*, Royal Academy of Arts, London, 1991; *Art on the Line*, Courtauld
Institute of Art, London, 2001–2.

This rarely-depicted classical scene from Homer's *Iliad* shows the Greek god
Apollo wooing the mortal Marpessa, whom he has wrested from her lover Idas.
Zeus intervened, allowing Marpessa to choose which lover she preferred; she
decided on Idas, for fear Apollo would desert her when she grew old. The drama
and ambivalence of the scene is well caught in the composition, the semi-nude
nymph Marpessa fleeing, vainly attempting to cover herself, and Apollo in
pursuit. The figure of the nymph is in high relief, her swirling drapery revealing
the form of her leg, and her upraised right arm acting as a counterpoint to
Apollo seizing her left. The barely sketched-in background of a pillar with
trailing vine leaves and rocky ground is typical of Flaxman's understated style.
Flaxman's earlier pen, ink and wash drawing of the subject included in addition
Idas in his chariot (Irwin 1980, fig. 234). The choice of subject also accords with
the sculptor's celebrated line drawings illustrating Homer. Flaxman is likely to
have executed this relief before he left Rome in 1794; its virtuoso carving meant
that it was a highly appropriate Diploma piece for the Royal Academy.

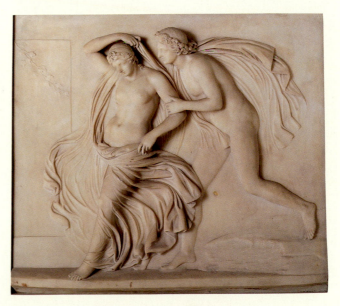

John Flaxman (1755–1826)
The Adoration of the Magi
c.1797, Marble, 22.5 x 42.6 cm, Private Collection, London.

Provenance Purchased by the present owners Christies South Kensington, London, 3 September 2003, lot 110.
Literature Bindman 2005

Autograph works by Flaxman in marble are rare, as in later life he adopted the 'pernicious practice of handing over the entire execution of the marble to workmen in the studio', so as to satisfy the demand for his funerary monuments and tablets. The finish and sensitivity of this piece (like the *Apollo and Marpessa*, no. 8) suggest it was worked by Flaxman himself. Two drawings (now at Yale and the British Museum respectively) and two plaster models associated with the composition are known, but its original destination or purpose are unclear. One of the plasters is in the Sir John Soane's Museum, and the other was formerly in the collections of University College London. This had been given to University College by Maria Denman, the artist's sister-in-law, in 1848, through the good offices of Flaxman's friend, Henry Crabb Robinson, one of the founders of the College. Presumed lost or destroyed by bombing in 1941, it was in fact presented as a 'diplomatic gift' by the Provost of University College to Virginia University in 1948 (files, Strang Print Room, UCL; I am grateful to Todd Longstaffe-Gowan for this information).Perhaps carved as a gift for his wife, Nancy, for whom he occasionally made special works, this marble could have been intended as a part of a series showing the life of Christ. Flaxman showed three plaster reliefs of scenes from the New Testament at the Royal Academy in 1797; two of these may be identified with plasetrs now in the College Art Collections, University College London (*The Flight into Egypt* and *The Three Marys at the Sepulchre*). The subject and style of the present relief was inspired by the fifteenth-century Italian painting and sculpture the artist had seen during his stay in Italy from 1787 to 1794, particularly the work of Masaccio and Jacopo della Quercia. Flaxman was a pioneer in his rediscovery of the Italian 'primitives', and this tender relief is one of the earliest works to show their influence.

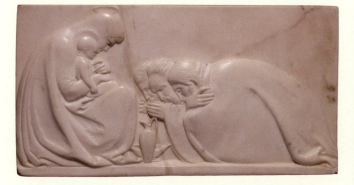

John Gibson (1790–1866)
Hylas surprised by the Naiads
c.1826–36, Marble, 160 x 119.4 x 71.8 cm, Tate, inv. no. NO1746

Provenance Presented to the National Gallery by Robert Vernon in 1847; transferred to Tate in 1897.
Literature *Descriptive Catalogue* 1848, p. 16; Matthews 1911, p. 66, and plate opposite p. 66; Hamlyn 1993, p. 10, and pp. 46–7 (cat. 29) (with earlier literature).
Exhibited Royal Academy of Arts, London, 1837 (cat. 1178); *Robert Vernon's Gift*, Tate Gallery, 1993 (cat. 29).

Gibson chiselled a Greek inscription on the marble pitcher held by the youth, which can be translated as 'Beautiful Hylas'. The story of Hylas comes from the Greek writer Theocritus: Hylas was the handsome youth and companion of Hercules, who accompanied him on the expedition of the Argonauts. As he was fetching water from a spring the water nymphs, or Naiads, who were bathing there were captivated by his beauty and pulled him into the water, so that he could always live with them. Gibson shows Hylas flanked by two nymphs, about to carry him off. Given Hylas's fate, the words of the inscription and their position on the pitcher suggest comparisons with the epitaph on Keats's grave in Rome, which Gibson would have known, 'here lies one whose name was writ on water.'

The painter J.M.W. Turner described the sculpture to Francis Chantrey in 1828 as 'two standing figures of nymphs leaning, enamoured, over the youthful Hylas'. Gibson's work was praised in the descriptive catalogue of the Vernon collection of 1848: 'Many as are the valuable productions of this celebrated sculptor, this work has long been known as one of the most poetically chaste he has ever executed.' Though this group is a male and two female figures, the composition distantly echoes the grouping of Canova's *Three Graces*, the sculptor exploiting the movement and interrelationship of the three nudes. Gibson related that he was modelling this piece when a 'Mr Haldiman' (actually the politician William Haldimand) visited his studio in Rome. The visitor later ordered a marble version, but then changed his mind, and Gibson subsequently sold it to the patron and collector Robert Vernon (1774/5–1849), who presented his collection, consisting primarily of modern British paintings, to the nation in 1847.

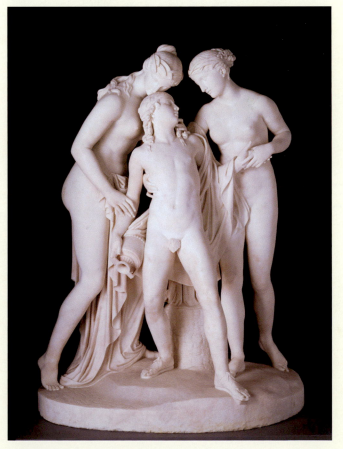

11

John Gibson (1790–1866)
Pandora
1856–61, Marble, 175 x 50 cm, National Museums, Liverpool, Lady Lever Art
Gallery, inv. no. LL 718

Provenance Commissioned by the 2nd Duke of Wellington, but declined;
order taken over by Lady Marian Alford; by descent to her younger son, 3rd
Earl Brownlow; his Executors' sale, Ashridge Park, Christie's, 3 May 1923 (lot
55); sold for £105. Bought by M. Harris & Sons, who sold it to the Lady Lever
Art Gallery for £110 5s.
Literature Clay, Morris et al. 1999, pp.35–40 (entry by T. Stevens, with earlier
literature); Bilbey and Trusted 2002, pp.273–4; Roscoe 2009 (forthcoming).
Exhibited International Exhibition, London, 1862.

According to Greek myth, Pandora, the first woman, was given a vase (or, as
here, a box) by Jupiter, who forbade her to open it. The vessel contained evils,
which were released into the world when Pandora disobeyed Jupiter's
injunction; only Hope remained. Here Pandora is shown at the point of opening
the box. This figure is one of Gibson's later works, and stylistically shows his
indebtedness to the pure classicism of one of the sculptors he most admired,
Canova.

The subject was originally commissioned by the 2nd Duke of Wellington,
who discussed it with Gibson when he visited the sculptor's studio in Rome.
The duke had suggested that Pandora was to be portrayed at 'the moment when
she comes to life ... nude, with some drapery hanging from her arm.' The box
was to be at her feet. He did not like Gibson's eventual composition, which,

according to the sculptor, shows Pandora 'as described by Hesiod, and with the
fatal box in her hand, drooping her head in deep thought' (Gibson's
Autobiography; see Matthews 1911, p. 188; see pp. 186–92 for Gibson's
complete account of his Pandora). The statue found, however, an owner in
Lady Marianne Margaret Compton (1817–88), who had married Viscount
Alford, later 2nd Earl Brownlow, and who was generally known as Lady Marian
Alford. A friend and admirer of Gibson, she had seen the progress of the
sculpture in Rome, and wanted to acquire it. The cost was £1050, the final
payment being made in April 1861. The surface of the marble was originally
partly coloured, although hardly any of the polychromy remains today. Gibson
experimented in tinting marble, partly in emulation of ancient Greek sculpture
which was originally coloured. The original pedestal of grey marble (not shown
here) was probably also designed by Gibson.

This, the primary version of the three statues of Pandora that Gibson
eventually sculpted, is signed in Greek: 'J. Gibson made in Rome'. Of the two
other versions, one was made for John Penn of the Cedars, Kent, and is now in
the Victoria and Albert Museum (Bilbey and Trusted 2002, cat. no. 418,
pp.273–4). A second repetition was ordered by George Hall Lawrence of
Mossley Hill (later Carnatic Hall), Liverpool. Its present whereabouts are
unknown; it is probably the version last recorded on the London art market in
1974. The present work was shown in a 'light, quadrangular temple' designed by
Owen Jones at the International Exhibition of 1862, alongside two other
sculptures by Gibson: his famous Tinted Venus (now Walker Art Gallery,
Liverpool) and Cupid, which was also coloured (now Cheltenham Art Gallery).

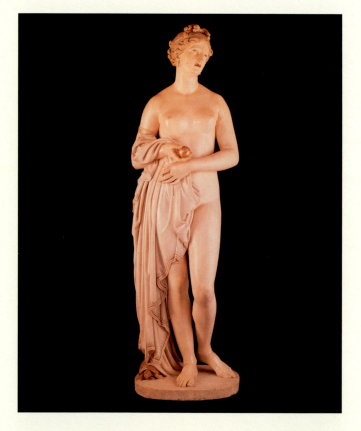

John Gibson (1790–1866)
Narcissus
Signed 1838, Marble, 108 x 71cm, The Royal Academy of Arts, London, inv. no. 03/1918

Provenance Presented by the artist to the Royal Academy as his Diploma piece in 1786.
Literature Guglielmi 1861, p. xiv; *Age of Neo-Classicism* 1972, pp. 239–40 (with earlier literature); Read 1982, pp. 200–1, and fig. 262 on p. 200; Stevens 1989, p. 58; Valentine 1991, pp. 73–4; Atterbury 1989, figs. 3, 41, 62 and 486.; Roscoe 2009 (forthcoming).
Exhibited Royal Academy of Arts, London, 1838 (cat. 1255); Royal Academy of Arts, London, Winter Exhibition, 1873 (cat. 269); Diploma Gallery, Royal Academy of Arts, London, 1939, (cat. 284); *The First Hundred Years 1769–1868*, Royal Academy of Arts, London, 1951 (cat. 708); *Sculpture 1850 and 1950*, London County Council [Holland Park], 1957; *Treasures of the Royal Academy*, Royal Academy of Arts, London, 1963 (cat. 230); Royal Academy of Arts, London, Bicentenary Exhibition, 1968 (cat. 135); *The Age of Neo-Classicism*, Royal Academy of Arts, London, 1972 (cat. 371); *From Reynolds to Lawrence: The First Sixty Years of the Royal Academy of Arts and its Collections*, Royal Academy of Arts, London, 1991.

Gibson sculpted several versions of the Greek mythological youth Narcissus, who fell in love with his own reflection. According to his own autobiographical reminiscences, in the early 1830s he saw a boy in Rome on the edge of a fountain 'looking into the water … The action was perfect for a statue of Narcissus'. The sculptor 'immediately went to [his] studio and modelled a small sketch in clay of the action which [he] had admired' (Matthews 1911, p. 83). Gibson spent the whole of his working life in Rome, where he lived from 1817 onwards, and revered both Canova (see nos. 4 and 5), in whose studio he worked for some time, and Thorvaldsen (see nos. 23–5). Canova himself advised the young British artist to study the Danish sculptor's work. The pure, almost Grecian style of this figure in particular recalls some of Thorvaldsen's own works, such as his *Shepherd Boy* of 1817, as well as being rooted in the artist's naturalistic observation of a boy seen by chance at a fountain. Gibson's sculpture was extremely popular, and reproductions of it were later made in Parian ware.

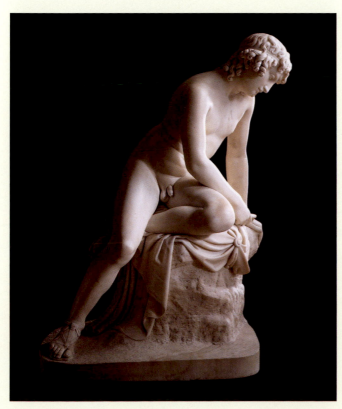

Francis Harwood (1726/7–83)
Bust of a Man
Signed and dated 1758, Black stone (*pietra da paragone*) on yellow Siena marble socle, 69.9 x 50.2 x 26.7 cm
The J. Paul Getty Museum, Los Angeles, inv. no. 88.SA.114

Provenance Possibly commissioned from the artist in 1758 by Hugh Percy, 1st Duke of Northumberland (1714–86); perhaps by descent to Algernon Percy, 4th Duke of Northumberland (1792–1865) of Stanwick Hall, Northamptonshire; sold at auction Anderson and Garland, Stanwick Hall, Yorkshire, May 1922, lot 189; sold Christies, London, 9 April 1987, lot 83; acquired by The J. Paul Getty Museum, from Cyril Humphris, 1988.
Literature *J. Paul Getty Museum Journal*, 17, 1989, p. 150; Villani 1991; Cremoncini 1992; *Getty Handbook* 1997, p. 266; Fusco 1997, p. 28; Bassett and Fogelman 1997, p. 14, illus; Baker 2000, p. 143 and fig. 112; *Getty Handbook* 2001, p. 265; Giusti 2006, p. 132; Foglemann in Panzanelli, Lapatin and Schmidt 2008 (forthcoming); Roscoe 2009 (forthcoming).
Exhibited *Arte e manifattura di Corte a Firenze …*, Palazzo Pitti, Florence, 2006 (cat. 60).

This magnificent bust was at Stanwick Hall, Northamptonshire in 1865, then the home of the 4th Duke of Northumberland. Its provenance prior to this date is uncertain, although it is reputedly the portrait of a black athlete named Psyche, who was in the service of the 1st Duke of Northumberland. Francis Harwood was British, but his exact origins and training are unknown. He travelled to Italy in 1752, and spent his working life in Florence, where he was renowned for his copies of antique sculpture (Cremoncini 1992). He was admitted to the Florentine Academy in 1755. Nollekens wrote to Thomas Banks in 1769, 'there is F.H. at Florence who is knocking the marbil about like feway & belive he as got more work to do than any One Sculptor in England' (Whiteley 1973, p. 41); Canova almost certainly visited his studio in 1779 (Honour 1959, p. 241). Harwood only sculpted a small number of original works, as opposed to copies of antique sculpture, including some elements of the Arch of the Porta San Gallo in Florence, and a tomb commemorating William, 2nd Earl Cowper (Belsey 1980). This bust is therefore exceptional, and indeed is enigmatic in terms of its intended context and hence meaning (see Baker 2000, p. 143). Roani Villani has pointed out that it is broadly in the tradition of Pietro Tacca's Moors on the fountain at Livorno, but at the same time it is clearly a portrait of an individual, portrayed in a noble, classicising manner. If the subject was indeed an athlete his bare chest would accord with that role, although such a representation recalls other nude busts of British aristocrats, such as Joseph Wilton's bust of Lord Chesterfield (no. 27), emulating the classical tradition of a sober unadorned portrait. Harwood was a friend of Wilton, who was active in Florence in the 1750s, and the undraped format also echoes Wilton's slightly earlier portrait of Dr Cocchi (no. 26). A second unpublished version of the present bust, formerly in the collection of Mrs Paul Mellon, is now at the Yale Center for British Art, New Haven. It is unsigned and undated, and seems to be a studio replica (I am grateful to Matthew Hargraves for his helpful comments on both versions.)

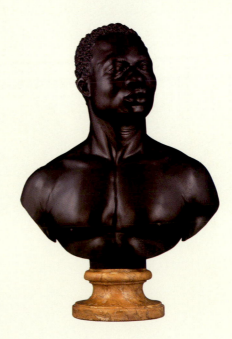

14

Christopher Hewetson (c. 1736–c. 1798)
Charles Townley (1737–1805)
Signed and dated 1769, Carrara marble, 57.5 x 34 cm
The British Museum, London, inv. no. MLA 1995,4-2,1

Provenance Commissioned by the sitter, perhaps at the suggestion of his brother, Edward Townley Standish; sold from the collection of the Rt. Hon. M.H. Towneley, 3rd Baron O'Hagan, Christie's, 8 June 1939, lot 80; estate of Lady Mary Strachey, early 1950s; known to have been in London in the 1960s; purchased with the assistance of the Art Fund and the British Museum Society, 1995.
Literature Ingamells 1997, p. 947; Dawson 1999, pp. 218–20 (with earlier literature).

Townley is one of the most important eighteenth-century collectors of classical sculpture; after his death his sculptures were bought for the nation at a cost of £20,000, and are now in the British Museum, where Townley himself served as a Trustee from 1791 until he died. When in 1816 the acquisition of the Parthenon marbles was being debated by the Select Committee of the House of Commons, the 'Townleyan Marbles' were reckoned to be 'the most valuable of the two' from a 'commercial point of view', although the 'Elgin marbles, as possessing that matter which most Artists require, claim a higher consideration' (*Report of the Select Committee* 1816, p. 14). Here he is represented in a relatively naturalistic style, wearing a wig and open shirt. The bust was executed on the first of his three visits to Italy of 1767–8, by the Irish sculptor Christopher Hewetson, who spent his working life in Rome, this being one of his earliest dated works.

15

Joseph Nollekens (1737–1823)
Mercury
1783, Marble, 106 x 68 x 36 cm, Lincolnshire County Council, The Collection: Art & Archaeology in Lincolnshire, inv. no UG1927/140

Provenance Probably commissioned by Charles Anderson Pelham, 1st Baron Yarborough in 1783 for £262 10s, and housed at Brocklesby Park, Lincolnshire; by descent; given by the Earl of Yarborough to the Usher Gallery, Lincoln in 1930.
Literature Smith 1828, I, p. 88, and II, pp. 78 and 80; *Gunnis* 1968, p. 277; *The Treasure Houses of Britain* 1985, p. 538; Lord 1988, p. 917, and fig. 34 on p. 915; Dictionary of Art 1996, 23, p. 189; Roscoe 2009 (forthcoming).
Exhibited Royal Academy of Arts, London 1783 (cat. 464).

Like the *Venus chiding Cupid* and *Sophia Aufrere* (nos. 16 and 18), this marble was purchased, and almost certainly originally commissioned, from the sculptor by Lord Yarborough. Nollekens's invoice was presented to Pelham on 10 May 1783. The marble is based on a classical source, the bronze seated Naples *Mercury*, discovered at Herculaneum in 1758, not long before Nollekens went to Rome (Haskell and Penny 1981, pp. 267–9). However, the life model was Nollekens's youthful assistant and later biographer, John Thomas Smith (1766––1833), who recorded one of his sittings in his biography of the sculptor. The young god sits on sensitively rendered drapery, complementing his relaxed, but strongly classicising pose. A finished terracotta model by Nollekens related to the marble was recorded on the art market in 1987. Nollekens had restored antiquities with Bartolomeo Cavaceppi in Rome, and this work prefigures Thorvaldsen's monumental Grecian style.

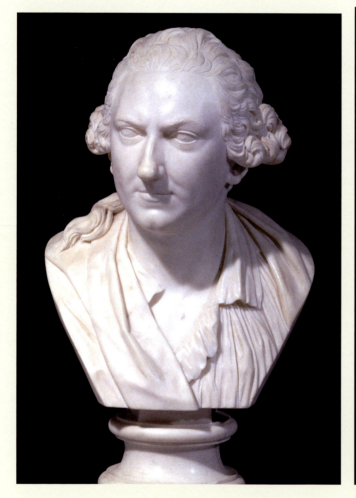

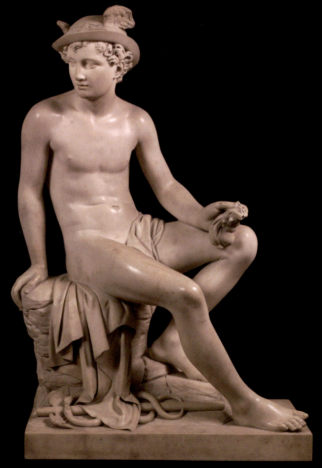

16

Joseph Nollekens (1737–1823)
Venus Chiding Cupid
Signed and dated 1778 (in Greek), Marble, 156 x 58 x 45.5 cm, Lincolnshire County Council, The Collection: Art & Archaeology in Lincolnshire. inv. no UG1927/137

Provenance Probably commissioned by Charles Anderson Pelham, 1st Baron Yarborough in 1778, and housed at Brocklesby Park, Lincolnshire; by descent; given by the Earl of Yarborough to the Usher Gallery, Lincoln in 1931
Literature Smith 1828, II, pp. 78 and 80; Irwin 1966, p. 56 and pl. 60; Gunnis 1968, p. 277; *The Treasure Houses of Britain* 1985, p. 538 ; Whinney 1988, p. 288, note 7 on p. 463, and fig. 205 on p. 290; Lord 1988, pp. 916–17, and fig. 35 on p. 916; *Dictionary of Art* 1996, 23, p. 189; Roscoe 2009 (forthcoming).
Exhibited Royal Academy of Arts, London, 1778 (cat. 216).

This ideal figure figure-group was almost certainly commissioned by one of Nollekens's most important patrons, Lord Yarborough, at about the same time that the sculptor was executing four statues of goddesses for Charles Watson-Wentworth, 2nd Marquess of Rockingham (1730–1782). Partly inspired by classical statuary, Venus's pose, gently inclining her head and bending her right knee, may also be indebted to the work of Giambologna (1529–1608). Drawings for the group survive in the Victoria and Albert Museum, showing that Nollekens re-thought the poses of these figures, and that he may have originally intended to produce a pendant figure of Mars. In the event, however, Lord Yarborough acquired a companion marble figure of the god from John Bacon the Elder (1740–1799), which is also now in the Usher Gallery. The plaster model for *Venus chiding Cupid* was exhibited at the Royal Academy in 1775. The composition is one of the earliest examples of a full-size ideal mythological figure-group by a British sculptor; Nollekens himself clearly thought highly of it. His biographer J.T. Smith recorded that 'Nollekens was so provoked by an accident which happened to one of his figures during the [Royal Academy] exhibition at Somerset House, that he threatened F.M. Newton, the Secretary, who made light of the affair, should this Venus be in any way injured, to break every bone in his body.' (Smith 1828, II, p. 80, note). Lord Yarborough probably met Nollekens in Rome in 1769, when he was on the Grand Tour, and shortly before the sculptor returned to England in 1770, having spent eight years studying and working in Italy. They became firm friends, and Nollekens received over thirty commissions for figures and busts from Pelham over the course of his career (see also cat. 15 and 18).

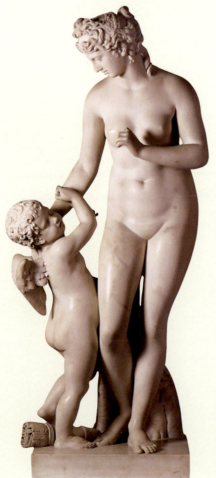

17

Joseph Nollekens (1737–1823)
Sir George Savile Bt. (1726–1784)
Signed and dated 1784, Marble, Ht. 75.9 cm., Victoria and Albert Museum, London, inv. no. A.16–1942

Provenance Chichester Constable Collection, Burton Constable Hall, Yorkshire; bought from the Chichester Constable Collection by Cecil Leitch & Kerin Ltd in 1932; sold by them to Dr W.L. Hildburgh F.S.A. the same year; Lent lent by Dr Hildburgh to the Victoria and Albert Museum 1933–1942; given to the Museum 1942.
Literature Bilbey and Trusted 2002, pp. 97—8 (with earlier literature); Roscoe 2009 (forthcoming).
Exhibited Perhaps Royal Academy of Arts, London, 1785

This is one of the finest of several known versions of this bust of the independent politician Sir George Savile, and is based on a death mask; on seeing this in Nollekens's studio, a contemporary remarked, 'pensiveness and spiritual suffering still left their mark on the tender, manly features' (von la Roche 1933, pp. 233–4). The naturalism of the facial features and hair is here combined with classical drapery, embodying a serious, commemorative portrait and at the same time evoking the sitter's public, political role. A portrait of Savile was shown at the Royal Academy in 1785, but it is not possible to confirm whether it was the present bust or one of the other contemporary versions.

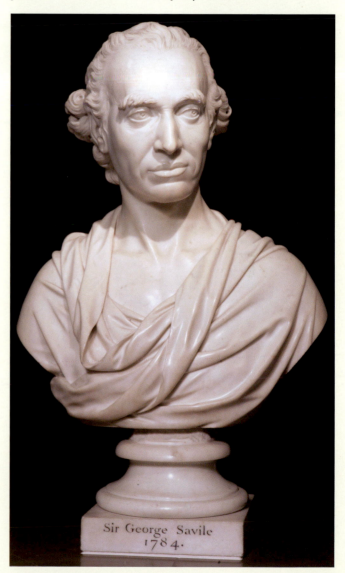

18

Joseph Nollekens (1737–1823)
Sophia, Daughter of George Aufrere (1754–86)
c.1785, Marble, 63.5 x 39 x 25.4 cm, Private collection

Provenance: Commissioned by Charles Anderson Pelham, 1st Baron
Yarborough *c*. 1785, housed at Brocklesby Park, Lincolnshire.
Literature: *The Treasure Houses of Britain* 1985, p. 538, cat. 475; Lord 1988, p.
918 and fig. 43 on p. 919; Roscoe 2009 (forthcoming).
Exhibited: *The Treasure Houses of Britain. Five Hundred Years of Private Patronage
and Art Collecting*, National Gallery of Art, Washington, 1985 (cat. 475).

Sophia Aufrere, Mrs Pelham, Lord Yarborough's wife, is portrayed here with an
elaborate classical-style headdress in the manner of what was thought to be an
antique head known as the *Zingara*, or Gypsy (Haskell and Penny 1981, pp.
339–41). The date of the bust is uncertain, but the contemporary hairstyle seen
in a drawing which is clearly related to the bust suggests it is from around 1785,
not long before Mrs Pelham died prematurely (she was buried in Brocklesby
Mausoleum, built by Wyatt). This is one of the most naturalistic neo-classical
busts: the turned head and lively features are subtly combined with the use of a
supposed classical source; in fact the *Zingara* dates from the early seventeenth
century.

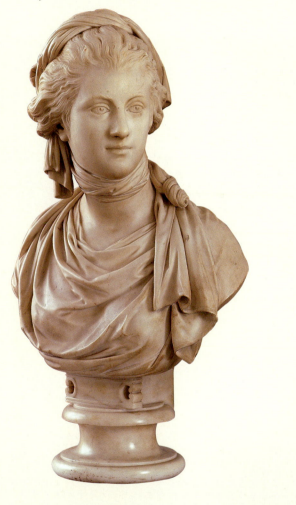

19

Benedetto Pistrucci (1783–1855)
Arthur Wellesley, 1st Duke of Wellington (1769–1852)
Signed and dated 1832, but probably after 1834, Marble, Ht. 53.5 cm
With kind permission of The Trustees of Stratfield Saye Preservation Trust

Provenance Commissioned by the Duke of Wellington; by descent to the
present owner.
Literature Trusted and Milano 2006, p. 16 (with earlier literature).
Exhibited Pistrucci's *Capriccio*, Sir John Soane's Museum, London, and
Waddesdon Manor, Buckinghamshire, 2006.

This bust is a slightly smaller copy of the over-lifesize portrait of the Duke at
Apsley House. Wellington sat for that version on 18 June 1832 (Waterloo Day),
the sculpture taking sixteen months to complete. Pistrucci said he worked 'as
long as [his] legs could bear my body, and [his] eyes didn't close from
exhaustion'. The present bust is of high quality, and is normally displayed on its
original red marble pedestal, which is inlaid with a small white marble relief of
the Battle of Waterloo. Apart from the Apsley House and Stratfield Saye
versions, another is in the United Services Club, London. Pistrucci's proficiency
in carving marble is amply demonstrated by this bold portrait: the crisp and
sensitive portrayal of the face and bare shoulders set on a herm-socle recall in
form and style Thorvaldsen's busts.

Pistrucci has added the words 'ROYAL MINT' after his signature, as he
commonly did on his marble portrait busts. He had been appointed Chief
Medallist at the Mint in 1828, having been employed there since 1817. A native
of Italy, he arrived in England in 1815. As a foreigner he could not be given the
post of Chief Engraver at the Mint, a source of bitterness to him, and probably
because of his own volatile temperament he was apparently frequently
discontented. His inscription on the small-scale marble *Capriccio* he made in
1829 refers to that time as the 'most unhappy years of [his] life'. His marble
sculptures are relatively rare; he specialised in working on a smaller scale:
cameos, waxes, as well as designs for medals and coins, including the gold
sovereign of George III of 1817. He also designed the great Waterloo Medal,
celebrating the Allies' victory. This design took many years to complete
(1819–49), but the medal was never in fact struck because it proved too difficult
technically.

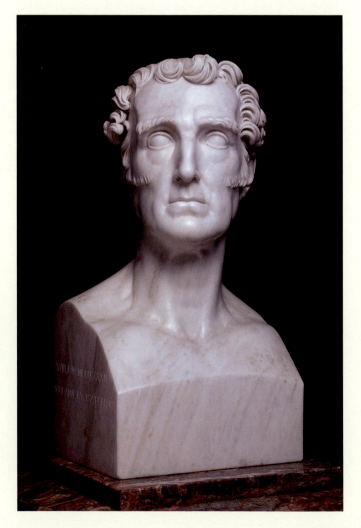

20

Hiram Powers (1805–73)
The Greek Slave

1844, Marble, 165.5 x 56 x 53.5 cm, The Rt Hon Lord Barnard TD, Raby Castle, Co. Durham. inv. no 1/26

Provenance Bought for £1,800 by the 2nd Duke of Cleveland in 1859. Bought by William, 7th Baron Barnard in London in 1845.
Literature Scott 1972, p. 18; Reynolds 1977, pp. 140–2; Atterbury 1989, figs. 4, 53, 100 and 856; *Dictionary of Art* 1996, 24, pp.400–2 (with earlier literature).
Exhibited London, 1845; The Great Exhibition, London, 1851.

This is the primary version of one of the most famous sculptures of the nineteenth century. The American sculptor Hiram Powers began work on this figure in 1841: it depicts a chained Greek Christian maiden standing naked in a Turkish slave market. In a pamphlet he issued at the time, Powers defended the nudity of the piece, which shocked many, by referring to the crucifix on the draped pillar against which the slave rests her hand, her faith in God shielding her from shame. The locket on the pillar alludes to the girl's lost loved ones. Powers wrote to a friend and patron in 1869, 'But as there should be a moral in every work of art, I have given to the expression of the Greek Slave what trust there could still be in a Divine Providence for a future state of existence … She is too deeply concerned to be aware of her nakedness.' The subject was also an allusion to the anti-slavery movement in America, and inspired many adulatory articles and poems when the sculpture toured America in 1847. Nor was it lost on critics that Powers was an American sculptor and that the enslavement of negroes still existed in the southern states of his homeland.
This work was shown at the Great Exhibition in London in 1851, and a version was exhibited in Paris at the Exposition Universelle in 1855. It was an immensely popular piece: Powers produced six other marble versions, and it was also reproduced in smaller variants in white biscuit, or Parian porcelain by Minton. The sculptor echoed the pose and ideal beauty of classical female nudes, and at the same time gave the subject a narrative which would appeal to Victorian audiences. America's most celebrated neo-classical sculptor, Powers had trained in America, but had left for Italy in 1837, and spent most of the rest of his working life in Florence.

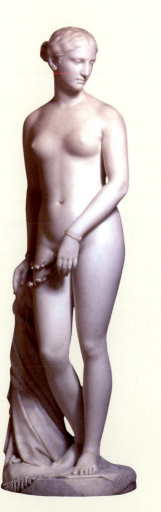

21

John Charles Felix Rossi (1762–1839)
The British Athlete

1828, Marble, Ht. 198 cm, Petworth House, The Egremont Collection (The National Trust

Provenance Commissioned by George (Wyndham), 3rd Earl of Egremont (1751–1837) for his sculpture gallery at Petworth House; thence by descent, until accepted in lieu of tax by H.M. Treasury in 1956, and subsequently transferred to the National Trust.
Literature Kenworthy-Browne 1977, p. 371, and fig. 10 on p. 369; *Petworth House* 1987, p. 28; *Metropole London* (cat. 417); *Dictionary of Art* 1996, 24, p. 197 (with earlier literature); Roscoe 2009 (forthcoming).
Exhibited Royal Academy of Arts, London 1828 (cat. 1209); *Metropole London/ London-World City 1800-1840*, Villa Hügel, Essen, 1992 (cat. 417).

Rossi's *British Athlete* formed part of the 3rd Earl of Egremont's collection of modern sculpture at Petworth House, and stood alongside marbles by Flaxman, Westmacott, Nollekens, Carew and others, and near the impressive collection of ancient sculpture acquired by Lord Egremont's father, Charles, the 2nd Earl. These collections are exceptionally still intact today in their original setting. Rossi's overlife-size sculpture, inscribed 'ATHLETA BRITANNICUS', recalls Canova's earlier *Pugilists* in the Vatican of 1801. It may even have been designed as a specifically British response to the Italian sculptor's more severely classical figure. Carved from a single piece of marble, it shows a heroic but probably contemporary boxer, his magnificent physique adorned only with tight-fitting shorts and sandals. It was greatly admired at the time, being described by J.T. Smith as 'truly vigorous and masterful'. At Petworth it stands near Rossi's earlier work made for Lord Egremont, *Celadon and Amelia* of 1821. Rossi had a mixed career, marked by some important commissions, but much financial hardship. In 1785 he had won a Royal Academy travelling studentship, at the same time as John Deare (see no. 7), and had spent three years in Rome. He was commissioned to carve two colossal stone lions for the western water-gate at Somerset House in 1790, and had undertaken several of the public monuments in St Paul's Cathedral between 1802 and 1825. He also worked as a designer and modeller for Coade in Lambeth, the manufacturers of artificial stone, until 1798, and for the Derby china works. Later, from 1819 to 1822, he executed terracotta caryatids for the Church of St Pancras in London. This marble shows him at his most severely neo-classical and heroic, imbuing a contemporary subject with the purity of the antique Roman style.

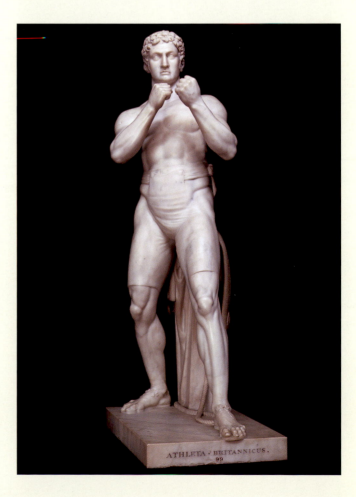

Johan Tobias Sergel (1740–1814)
Diomedes
Signed and dated 1774
Marble
Ht. 150 cm
Nationalmuseum Stockholm, inv. no. Nm Sk1475

Provenance Commissioned by Thomas Mansel Talbot in 1773, and delivered to his seat, Margam Abbey, West Glamorgan, Wales in June 1775; sold Christie's London, 29 October 1941, lot 458; bought by the Swedish ambassador, Björn Prytz, and presented by him to the Nationalmuseum Stockholm in 1941.
Literature *Age of Neo-Classicism* 1972, pp. 280–1, cat. 436 (with earlier literature); *Sergel* 1990, pp. 197–201 (with earlier literature); *Dictionary of Art* 1996, 28, p. 462; Ingamells 1997, p. 924; Scott 2003, p. 141; *Sergel* 2004, p. 61.

The Greek hero Diomedes, nude except for the cloak over his left arm, holds his stolen trophy, the Palladium, a statuette of the goddess Athena, in his left hand, as he hastens away; his theft of the image of Athena would lead to the fall of Troy. The story is ultimately taken from Virgil's *Aeneid*, but Sergel used as his direct source the contemporary version of the classical text by the Comte de Caylus, *Tableaux tirés de l'Illiade, de l'Odyssée d'Homère et de l'Eneide de Virgile* (1757). Sergel had started work on the commission by 1772, and two terracotta models for the marble are in the Nationalmuseum, Stockholm. The young

Count F.A.U. Cronstedt wrote to his father, the surintendant Carl-Johan Cronstedt, from Rome on 23 May 1772: 'Father, you cannot believe how much it pains me to see his figure of Diomedes going to England.' The anxiety of the young count reflected the impact that the *Diomedes* had on visitors in Rome. Sergel was admired not only as a great sculptor in his own right, but as an interpreter of the antique in modern terms.

The pose of this single figure is itself dramatic, and suggests both the guilt and determination of the protagonist. It was partly inspired by one of the figures in the antique group *Castor and Pollux*, which the artist would have known through a full-sized cast in the French Academy in Rome (the original marble had been acquired earlier in the eighteenth century by Philip V of Spain, and is now in the Prado in Madrid). Sergel was a native of Sweden, and went to study in France in 1758. In 1767 he journeyed to Rome, where he stayed for eleven years, and found his true style, acquiring a European reputation as a neo-classical artist. There he became a friend of Fuseli among others. In 1778 he went to Paris once more, and in 1779 returned to Stockholm, where he was to become Director of the Academy of Fine Arts in 1810. The patron who commissioned *Diomedes*, Thomas Mansel Talbot (*c.*1747–1813), went to Italy three times; this sculpture was commissioned during his third visit. He spent the enormous sum of £7,397 on works of art in Italy, but apparently the marbles he purchased were 'left in packing cases during the greater part of [his] life' (Ingamells, p. 924, citing Michaelis).

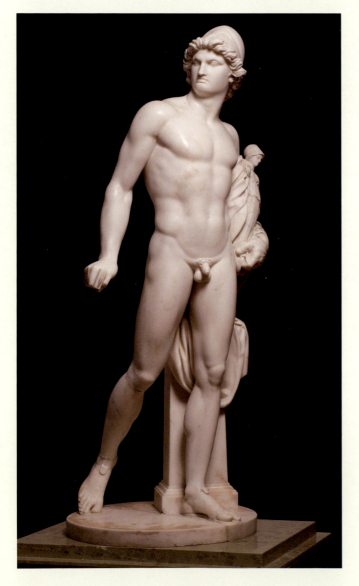

23

Bertel Thorvaldsen (1768/70–1844)
Lady Georgiana Russell as a Child (1811–67)
1815, Marble, 114 x 360 x 310 cm
By kind permission of His Grace the Duke of Bedford and the Trustees of the
Bedford Estates, inv. no 5246

Provenance: Commissioned from the artist in Rome by John Russell, 6th Duke
of Bedford.
Literature: *Outline Engravings* 1822, unpaginated; Waagen 1854, III, p. 472,
Letter XXXIII; Honour and Weston-Lewis 1995, fig. 60 on p. 66, and p. 67;
Yarrington 2002; Roscoe 2009 (forthcoming).

This full-length, life-size figure of the 6th Duke of Bedford's daughter,
Georgiana, at the age of four was commissioned from the Danish sculptor Bertel
Thorvaldsen in Rome in 1815. It became a pendant to the figure of Georgiana's
sister Louisa (see no. 6), executed two years later, and both were placed on
either side of the entrance to the Temple of the Graces at Woburn. Alison
Yarrington has persuasively argued that the representations of the Duke's two
daughters provided the earthly counterparts to the heavenly sister Graces by
Canova within the temple (see no. 5). Thorvaldsen's rendering of the almost
nude static infant parallels, and at the same time contrasts with, the intertwined
Three Graces. Waagen called this work 'extremely pleasing from the simple
design and the natural infantine expression'.

24

Bertel Thorvaldsen (1768/70–1844)
The Three Graces
After 1819, Marble, Ht. 115 cm; W. 97 cm; D. 19.5 cm (without surround), Ht.
125 cm; W. 111 cm; D. 19.5 cm. (with surround), Touchstones Rochdale Art
Gallery, inv. no 275

Provenance Bought from the sculptor by Dr Nevinson; sold at Dr Nevinson's
sale, London, 22–23 April 1847; bought by Edward Cheney of Badger Hall,
Shropshire; by descent at Badger Hall to Francis Capel-Cure; sold Christie,
Manson and Woods, 4–5 May 1905, lot 232; bought by Sir Thomas Sinclair.
Donated to Rochdale Art Gallery in 1913 by Robert Taylor Heape.
Literature: Knox 2007, fig. 3, p. 7, p. 8, p. 14 and note 31 on p. 19.

Thorvaldsen had executed a freestanding group of *The Three Graces* in 1819,
shortly after Canova's groups made for Prince Eugène de Beauharnais and the
6th Duke of Bedford respectively. The Danish sculptor had thought Canova's
composition 'delightful, but disapproved of the restless confusion of arms when
the group was viewed from behind.' (Salling, p. 215). This smaller relief is a
variant of the freestanding composition, with the central figure tellingly shown
from the back, her arms harmoniously draped around her companions, one of
whom is seen from the side and the other facing the viewer, providing three
different views of the female nude. In contrast to the representations by Canova,
here the figures are shown listening to Cupid playing the lyre, no doubt a
reference to the lyrical harmony of the Graces. The relief is mounted in a grey
marble setting, dating from the early twentieth century. Thorvaldsen, who had
trained in Copenhagen, won a travelling scholarship to Rome in 1793, and
arrived in the Eternal City in 1797. He spent much of the rest of his life there,
earning many commissions from British visitors (see nos. 23 and 25), and
exerted a strong influence on British sculptors in Rome, notably Gibson and
Wyatt (see nos. 10–12 and 28). He was feted by his fellow Danes, and after his
return to Denmark in 1838, the Thorvaldsen Museum was built to house his
works in Copenhagen.

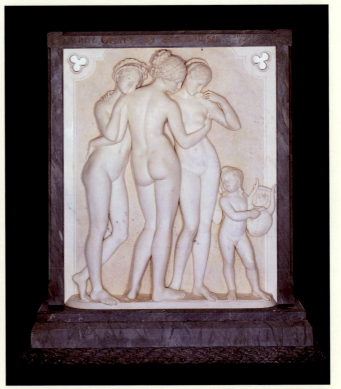

Bertel Thorvaldsen (1768/70–1844)
Sir Walter Scott (1771–1832)
1833/4, Marble, Ht. 58 cm, The Scottish National Portrait Gallery, Edinburgh, inv. no PG2933

Provenance Probably owned by 'Dr Nevinson', a patron of the sculptor; Dr Neivinson's sale, London, 22–23 April 1847; bought by Edward Cheney of Badger Hall,. Shropshire; by descent to Francis Capel-Cure; Christie, Manson and Woods, London, 4–5 May, 1905, lot 230, sold to Agnew, 58 guineas; probably sold to Charles Fairfax-Murray; London art market 1993; Knox and Longstaffe-Gowan collection 1993; purchased by the Scottish National Portrait Gallery 1994.
Literature Knox and Longstaffe-Gowan 1993.

Thorvaldsen and Scott met in Rome in 1832, as the writer was nearing the end of his life; both men were widely known throughout Europe for their respective artistic achievements, and had a great mutual admiration. When their meeting took place they gazed 'at each other for a moment in silence, with inexpressible satisfaction beaming in their countenances'. On the basis of this relatively brief encounter Thorvaldsen executed what became a posthumous portrait bust of the Scotsman. A full-size plaster model with drapery is in the Thorvaldsen Museum in Copenhagen. This finished marble is of a simple herm form; the subject, with short hair, looking somewhat younger than his actual age of just over sixty years, gazes straight ahead. It is a distinguished portrait of restrained idealism, typical of the Danish artist's work.

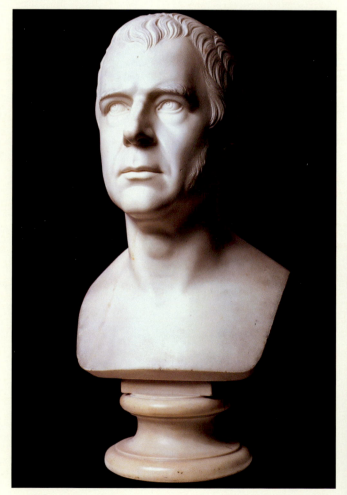

Joseph Wilton (1722–1803)
Dr Antonio Cocchi (1695–1758)
Signed and dated 1755, Marble, 61.3 x 44 x 20cm
Victoria and Albert Museum, London, inv. no. A.9-1966

Provenance Commissioned from the sculptor by Francis Hastings, 10th Earl of Huntingdon (1739–89), and recorded at his seat, Donnington Hall, Castle Donnington, Leicestershire in 1768; later in the collection of Sir Ian Wakeover Bt, at Okeover Hall, Ashbourne, Derbyshire; sold Christie's London, 30 June 1966, lot 14; purchased by the Museum from Cyril Humphris Ltd in 1966.
Literature Bilbey and Trusted 2002, pp. 161–2 (with earlier literature); Wilson 2004, pp.12–22, and fig. 23 on p. 14; Roscoe 2009 (forthcoming).
Exhibited *Norfolk and the Grand Tour …*, Castle Museum, Norwich, 1985.

Although this bust is dated 1755, this may record the date of the sitting, as it was not in fact completed until 1756, after Wilton's return to London. It formed a pendant to the bust of Lord Huntingdon (Government Art Collections, currently on loan to the Victoria and Albert Museum), and celebrated the friendship of the two men, Huntingdon an aristocratic Grand Tourist, and Cocchi, a widely-respected physician and scholar in Florence, who befriended many of the British visitors to the city. Dr Cocchi also had a serious interest in art, and was Keeper of the Grand-Ducal collections in Florence. The Greek inscription on the medallion on the socle can be translated as 'Antonio Cocchi/ Age 60/ 1755/ I go on learning as I grow old'. The bald and bare-chested sitter is depicted in a highly animated and naturalistic style, though the austere representation recalls at the same time antique Roman busts. The sensitive carving of the flesh in particular also recalls the work of the great French sculptor Jean Baptiste Pigalle (1714–85), under whom Wilton had worked in Paris from 1745 to about 1749. A contemporary notice in the *Critical Review* of 1756 recorded that Wilton had 'almost finished a fine expressive bust of the learned Cocci [sic.], member of the Academy of *Florence*, to whose labours the world of Literature, and Medicine in particular, has been greatly indebted'. The author noted that Wilton combined 'the strength and accuracy of a *Bona Rota* [Michelangelo Buonarroti] with all the taste and delicacy of a *Bernini*' (I, p. 387). A bronze version of this bust was incorporated into the monument to the sitter in Santa Croce in Florence. Dr Cocchi's bust is reminiscent too of Wilton's portrait of the Englishman Thomas Hollis of *c.* 1758–62 (now on long-term loan to the National Portrait Gallery), similarly shown without drapery. Hollis, like Cocchi, was a connoisseur, and Wilton may have deliberately portrayed both men in a similar fashion (Wilson 2004, p. 16).

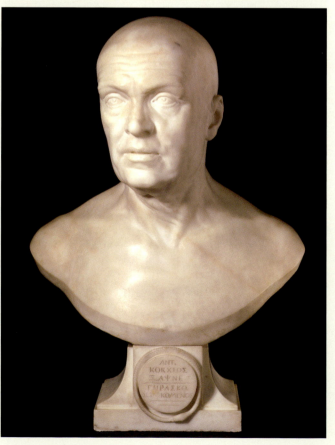

27

Joseph Wilton (1722–1803)
Philip Dormer Stanhope, 4th Lord Chesterfield (1694–1773)
Signed and dated 1757, Marble, with cast gilt lead alloy badge, 65 x 42.7 cm
The British Museum, inv. no. MLA 1777,6-20,1

Provenance Probably commissioned by the sitter in 1757; given by Lord Chesterfield to Sir Thomas Robinson Bt; bequeathed by Robinson to the British Museum in 1777.
Literature Dawson 1999, pp. 66–8 (with earlier literature); Wilson 2004, especially pp. 12–14, and fig. 22 on p. 14; Roscoe 2009 (forthcoming).
Exhibited : *British Portraits*, Royal Academy of Arts, London 1956–7, (cat. 331); *Eighteenth Century Portrait Busts*, Iveagh Bequest, Kenwood, London, 1959 (cat. 39).

Wilton's training in France in the 1740s meant that he had a lively understanding of both contemporary French sculpted portraiture, such as the work of Jean-Baptiste II Lemoyne (1704–78) and Jean-Baptiste Pigalle (1714–85), and classical prototypes. The turn of the head and alert expression, as well as the detailed observation of the texture of the sitter's skin, give an immediacy to the piece. His training in Italy in the 1750s was equally important. The lack of wig and bare shoulders evoke classical busts and impart a heroic quality to the bust (compare no. 13 and 26, Harwood's *Bust of a Man* and Wilton's own *Dr Cocchi*), reminiscent of Roman republican portraits. The sensitive carving of the marble is typical of Wilton's finest work; he was arguably the greatest native-born sculptor working in Britain in the second half of the eighteenth century. Lord Chesterfield is perhaps best known today for the letters written to his illegitimate son Philip Stanhope. He was a leading politician and statesman, and in 1730 was made Knight Companion of the Order of the Garter.

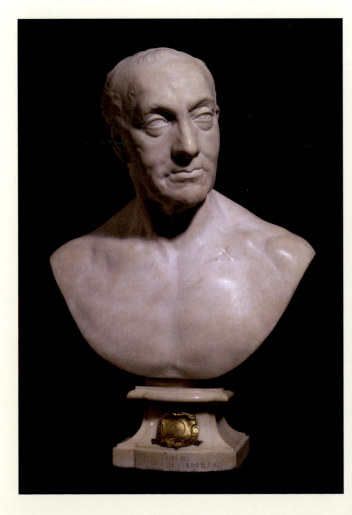

28

Richard James Wyatt (1795–1850)
Flora and Zephyr
1834, Marble, Ht. (without base) 160 cm; W. 81 cm
Nostell Priory, The St Oswald Collection (The National Trust)

Provenance Commissioned by Sir Robert Lawley, 1st Lord Wenlock of the first creation (1768–1834) for Escrick Park, Yorkshire; bought by Charles Winn (1795–1874) of Nostell Priory after Lord Wenlock's death at his villa near Florence in April, and the group's exhibition at the Royal Academy in the summer of 1834; thence by descent, until acquired with some of the principal contents of Nostell Priory by the National Trust in 1986, with the aid of a grant from the National Heritage Memorial Fund.
Literature *Nostell Priory* 1981, p. 12; Robinson 1979, p. 166 and fig. 97 on p. 167; *Dictionary of Art* 1996, 33, pp. 448–9; Roscoe 2009 (forthcoming).
Exhibited Royal Academy of Arts, London, 1834 (cat. 1080)

Wyatt specialised in ideal marble figure-groups, some, like this one, of mythological subjects, others derived from post-classical literary sources. Here Flora, the goddess of flowers, is shown with her young husband, the god Zephyr, the west wind of Springtime, who sports butterfly wings. The sculptor replicated this group later, and also sculpted a single figure of Flora, based on the one here, but this marble is thought to be the primary version, first shown at the Royal Academy in 1834. During the 1830s Wyatt produced some of his finest work, perfecting the polished finish of the marble surface, which he did without the help of assistants, in the tradition of Canova's working practice. He also learnt the technique of carving and polishing marble from the French sculptor Baron François-Joseph Bosio (1769–1845), with whom he worked in Paris briefly on his way to Rome. He had been apprenticed to Rossi initially in London (see no.21), but had left England for Rome via Paris in 1820. He arrived in the Eternal City in 1821, where he worked in Canova's studio, before moving to study under Thorvaldsen after Canova's death in 1822. In Rome he met and became a friend of the slightly older sculptor John Gibson (see nos. 10–12), and both artists spent their working lives there, emulating the neo-classical style in the traditions of both Canova and Thorvaldsen, striving to depict ideal beauty.

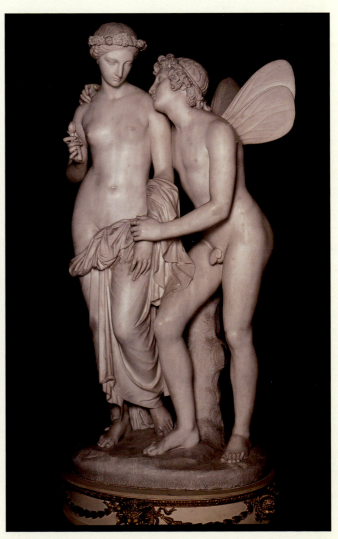

Anonymous ancient Roman fragments, restored in Rome
Bacchus and a Panther
c.1730
Marble, Ht. 213 cm,
Anglesey Abbey, The Fairhaven Collection (The National Trust); inv. no.
AA/SC/111

Provenance The antique Roman elements (the head, feet, parts of the panther and plinth) were probably excavated in Rome or its environs, with new parts being added by an eighteenth-century Italian sculptor, almost certainly in Rome (see below); bought by the Hon. Charles Hamilton (1704–1786) of Painshill, Surrey between 1732 and 1735 for about £2000; sold with Painshill to Benjamin Bond-Hopkins in 1773; at his death, knocked down by Christie's on 23 October 1797 to the sculptor Joseph Nollekens [q.v.], acting for William Beckford (1760–1844) for Fonthill Splendens, Wiltshire for £400; bought by Mr Abbott for 200 guineas on behalf of Thomas Johnes (1748–1816) of Hafod, Cardiganshire, on the sixth day of the sale of Fonthill Splendens held by Phillips, on 17 August 1807 (lot 623); the Hafod estate was bought by the 4th Duke of Newcastle in 1832, who ordered the Bacchus to be transported to London and auctioned at Christies in 1839, but no record of its sale or subsequent purchase has been found; later (perhaps around 1857 when pleasure gardens were being set out) in the collection of the Earls Brownlow at Ashridge Park; sold on 2 October 1928 at an auction of Garden Ornaments held by Perry & Phillips for £13; purchased on 23 September 1929 for £150 from Crowther & Son by Urban Huttleston Broughton, 1st Baron Fairhaven (1896–1966), elder son of Urban Hanlon Broughton M.P. (1857–1929), who had acquired Ashridge Park the previous year; installed by Lord Fairhaven at Anglesey Abbey, Cambridgeshire, and bequeathed by him to the National Trust, along with the house, its contents and the grounds with their garden sculpture, on the death of Lord Fairhaven in 1966.
Literature Parnell 1763; Whately 1770; Cambray 1788; *Gentleman's Magazine,* October 1797, p. 816b; Britton 1801, pp. 223–4; Warner 1801, p. 126; Woodbridge 1965, p. 109; Roper 1964, p. 40 and pl. 13b (as Apollo); Garlick and Macintyre 1978–84, III, p. 921; Kitz 1984; Symes 1994, pp. 32 and 34; Spence *Anecdotes* [1820, but widely circulated in manuscript in the lifetime of the author (1699–1768)], quoted in Ingamells 1997, pp. 446; *Anglesey Abbey Gardens* 1997, p. 21; P. Hewat-Jaboor, 'Clinging fast "to my tutelary mountains"' in Ostergard 2001.

This is one of the most interesting examples of an early eighteenth-century pastiche of the antique, which incorporates Roman fragments. Many such works were sold to British visitors in Rome. Most purchasers assumed they were buying fundamentally ancient sculptures, unaware that they were in effect modern, having been heavily re-carved and restored in the seventeenth and eighteenth-century, in some cases by important sculptors. Bartolomeo Cavaceppi (1716–1799) was perhaps the most notorious manufacturer of these hybrids. In the case of the Bacchus, the life-size head was probably originally that of a Roman goddess, but has been re-carved as a male head, and attached to the over life-size body of Bacchus, whose torso, arms and legs were probably

carved by an Italian sculptor in the 1720s in Rome. The left foot, the lower third of the tree trunk, the hind part and front left paw of the panther are probably ancient Roman, though re-carved and polished by the eighteenth-century restorer, the snout of the animal resembling a dog rather than a panther, Bacchus's usual familiar. The pose of the figure has been borrowed from the Lycian Apollo, a type much copied in the Greek and Roman world, deriving ultimately perhaps from a work by Praxiteles of 340–330 BC. The statue is currently being restored by the National Trust for display indoors, possibly in the Temple of Bacchus at Painshill, which there are plans to reconstruct. The peregrinations of the Painshill Bacchus – from prized Grand Tour trophy to exile in a Cambridgeshire garden – perfectly mirror the critical and aesthetic fortunes of so much of the Graeco-Roman sculpture that inspired the sculptors of the neoclassical era.

On its arrival in Britain, this statue, whose history has only recently been pieced together (by Jan Clark, Philip Hewat-Jaboor, Norman Kitz, and Alastair Laing respectively), was placed in the centre of the Temple of Bacchus, built for it, in the grounds of Painshill, Cobham, Surrey. The owner, the Hon. Charles Hamilton, is said to have paid the exceptionally high price of over £2,000 for the sculpture. Hamilton visited Rome twice, in 1725–6 and in 1732–5, and probably bought the Bacchus on his second visit. Joseph Spence noted in a letter that he 'kept company much with the nobility of the country. Bought his noble Bacchus of one of them with a promise of secrecy.'(Ingamells 1997, p.446). The secrecy may have been to evade the strict export laws then enforced in eighteenth-century papal Rome, but Hamilton could well have been duped by the vendor into thinking it was a recently excavated ancient marble, rather than one just cobbled together. However, at Painshill it was much admired by visiting travellers, including Henry Hoare of Stourhead (1705–1785), who called it a 'Noble Statue' in a letter to his daughter of 1762. Thomas Whately lauded the sculpture in 1770, describing its setting in 'a large Doric building …with a fine portico in the front …within, it is decorated with many antique busts and a noble statue of the god in its centre.' In 1773, Hamilton was obliged to sell Painshill, complete with many of its contents, including the Bacchus due to financial difficulties. The sculpture was subsequently sold at auction on the death of Painshill's next owner, Benjamin Bond-Hopkins, when it was acquired by that other lover of virtù, Charles Hamilton's great-nephew, William Beckford (1760–1844). Beckford originally installed it in his newly-built Fonthill Abbey, but it was damaged there when a tower collapsed on 10 May 1800, so he had it repaired, and installed it in a niche in the dining room of his father's Palladian mansion, Fonthill Splendens, Wiltshire. When 'this old palace of tertian fevers' was demolished in 1807, it was auctioned on 17 August, and acquired for his master by the steward of another notable collector of sculpture, Thomas Johnes (1748–1816) of Hafod, Cardiganshire, a patron of both Gibson and Chantrey. Disappearing after Hafod's next owner, the 4th Duke of Newcastle, gave orders for it to be dispatched it to London to be auctioned at Christie's, where it seems never to have arrived, it found its way at an unknown date to another Wyatt house, Ashridge Park, embarking on a new career as a garden ornament. I am grateful to Tony Herridge, Tim Knox, Andreas Kropp, and Trevor Proudfoot for much valuable information on the sculpture and its history.

Bibliography

'Acquisitions/1988: Sculpture and Works of Art', *The J. Paul Getty Museum Journal*, 17, 1989, no. 90

The Age of Neo-Classicism (exh. cat.), Arts Council of Great Britain (Royal Academy and the Victoria and Albert Museum), London 1972

L.D. Ambrosini and R.A.G. Reynolds, *Hiram Powers: Genius in Marble* (exh. cat), Taft Museum of Art, Cincinnati 2007

Anglesey Abbey Gardens, London 1964

Art in Rome in the Eighteenth Century (exh. cat.) ed. E.P. Bowron and J.J. Rishel, Philadelphia Museum of Art, Philadelphia, 2000

P. Atterbury (ed.), *The Parian Phenomenon. A survey of Victorian Parian Porcelain Statuary and Busts,* Shepton Beauchamp 1989

M. Baker, *Figured in Marble: The Making and Viewing of Eighteenth-Century Sculpture,* London 2000

M. Baker, 'An Anglo-French Sculptural Friendship: Pigalle and Wilton' in G. Bresc-Bautier, F. Baron and P.Y. Le Pogam (eds.), *La sculpture en Occident. Études offertes à Jean-René Gaborit,* Dijon, 2007, pp. 218-25.

M. Baker, ' "No cap or wig but a thin hair upon it": Hair and the Male Portrait Bust in England around 1750', *Eighteenth-Century Studies* 38, 2004, pp. 63-77.

J. Bassett and P. Fogelman, *Looking at European Sculpture: A Guide to Technical Terms,* Los Angeles, 1997

C.F. Bell (ed.), *Annals of Thomas Banks, sculptor, Royal Academician, with some letters from Sir Thomas Lawrence to Banks's daughter,* Cambridge, 1938

H. Belsey, 'A newly discovered work by Francesco Harwood', *Burlington Magazine,* CXXII, 1980, pp. 65-6

D. Bilbey with M. Trusted, *British Sculpture 1470 to 2000. A concise catalogue of the collection at the Victoria and Albert Museum,* London 2002

D. Bindman (ed.), *John Flaxman* (exh. cat.), Royal Academy of Arts, London 1979

D. Bindman, *Ape to Apollo. Aesthetics and the Idea of Race in the 18th Century,* London 2002

D. Bindman, 'John Flaxman's "Adoration of the Magi" rediscovered', Apollo, CLXII, December 2005, pp. 40-44

J. Britton, *The Beauties of Wiltshire,* London 1801

J. Bryant, 'The Royal Academy's "violent democrat"':. Thomas Banks', *The British Art Journal,* VI, no. 3, Winter 2005, pp. 51—8

J. Bryant, *Thomas Banks 1735–1805: Britain's First Modern Sculptor* (exh. cat.), Sir John Soane's Museum, London 2005

J. de Cambry, *De Londres et de ses environs,* Amsterdam 1788

M. Clarke and N. Penny (eds.), *The Arrogant Connoisseur: Richard Payne Knight 1751–1824* (exh. cat.), Whitworth Art Gallery, Manchester 1982

A. Clay, E. Morris et al., *British Sculpture in the Lady Lever Art Gallery,* Liverpool 1999

R. Cremoncini, *Francis Harwood: Scultore Inglese a Firenze nel Settecento* (unpublished doctoral thesis), University of Siena 1992

G. Cumberland, *Outlines from the Antients …,* London 1829

A. Cunningham, *The Lives of the Most Eminent British Painters and Sculptors* (5 vols.), New York 1831

A. Cunningham, *The Life of Sir David Wilkie* (3 vols.), London 1843

A. Dawson, *Portrait Sculpture: A Catalogue of the British Museum Collection c. 1675–1975,* London 1999

Descriptive Catalogue of the Vernon Gallery, London 1848

The Dictionary of Art (34 vols.), ed. J. Turner, London 1996

J. Farington, *The Diary of Joseph Farington* (16 vols.), eds. K. Garlick, A. Macintyre and K. Cave, New Haven, 1978–84

J. Flaxman, *Lectures on Sculpture …,* London 1838

P. Fogelman and P. Fusco, *Masterpieces of Sculpture in the J. Paul Getty Museum,* Los Angeles 1998

P. Fogelman, P. Fusco and S. Stock, 'John Deare (1759–1798): A British Neo-classical Sculptor in Rome', *Sculpture Journal,* IV, 2000, pp. 85–126

P. Fusco, *Summary Catalogue of European Sculpture in the J. Paul Getty Museum,* Los Angeles 1997

K. Garlick and A. Macintyre, *The Diary of Joseph Farington* (16 vols), New Haven 1978–84√

George Bullock: Cabinet-maker (exh. cat.), introduction by C. Wainwright, H. Blairman & Sons, London 1988

The J. Paul Getty Museum Handbook of the Collections, Los Angeles 1997

The J. Paul Getty Museum Handbook of the Collections, Los Angeles 2001

A. Giusti (ed.), *Arte e Manifattura di Corte a Firenze dal Tramonto dei Medici all'Impero* (exh. cat.), Palazzo Pitti, Florence 2006

P. Guglielmi, *Engravings from the Original Compositions executed in Marble at Rome by J. Gibson and drawn by P.G.,* London 1861

R. Gunnis, *Dictionary of British Sculptors 1660–1851,* London 1968

R. Hamlyn, *Robert Vernon's Gift: British Art for the Nation 1847* (exh. cat.), Tate Gallery, London 1993

F. Haskell and N. Penny, *Taste and the Antique. The Lure of Classical Sculpture 1500–1900,* New Haven 1981

H. Hawley and R.G. Saisselin, *Neo-classicism:. Style and Motif* (exh. cat.), The Cleveland Museum of Art, 1964

H. Honour, 'Antonio Canova and the Anglo-Romans. Part 1: the first visit to Rome', *Connoisseur,* CXLIII, 1959, pp. 241—5

H. Honour, *Neo-classicism,* Harmondsworth 1977

H. Honour and A. Weston-Lewis, *The Three Graces* (exh. cat.), National Gallery of Scotland, Edinburgh 1995

S. Howard, *Antiquity Restored: Essays on the Afterlife of the Antique,* Vienna 1990

Ickworth Suffolk, The National Trust, London 1976

J. Ingamells, *A Dictionary of British and Irish Travellers in Italy 1701–1800,* New Haven 1997

D. Irwin, *English Neoclassical Art: Studies in Inspiration and Taste,* London 1966

D. Irwin, *John Flaxman 1755-1826: Sculptor, Illustrator, Designer,* London 1980

J. Kenworthy-Browne, 'The Third Earl of Egremont and Neo-Classical Sculpture', *Apollo,* CV, May 1977, pp. 367–73

N. and B. Kitz, *Pains Hill Park: Hamilton and his Picturesque Landscape,* Cobham 1984

T. Knox, 'Edward Cheney of Badger Hall: a forgotten collector of Italian sculpture', *Sculpture Journal,* Vol. 16.1 (2007), pp.5–20.

T. Knox and T. Longstaffe-Gowan, 'Thorvaldsen's "Valdrescot". A lost bust of Sir Walter Scott discovered', *Apollo,* CXXXVII, February 1993, pp. 75—81

C.R. Leslie, *Autobiographical Recollections,* ed. T. Taylor (introduction by R. Hamlyn) East Ardsley 1978

J. Lord, 'Joseph Nollekens and Lord Yarborough: documents and drawings', *Burlington Magazine,* CXXX, December 1988, pp. 915–19

T. Matthews, *The Biography of John Gibson, R.A., Sculptor, Rome,* London 1911

Metropole London/ London-World City 1800-1840 (exh. cat.), ed. C. Fox, Villa Hügel, Essen 1992

Nostell Priory Yorkshire, The National Trust, London 1981

D.E. Ostergard (ed.), *William Beckford 1760–1844: An Eye for the Magnificent* (exh. cat), Bard Graduate Center for Studies in the Decorative Arts and Dulwich Picture Gallery, New Haven 2001

The Oxford Dictionary of National Biography (60 vols.), ed. H.C.G. Matthew and B. Harrison, Oxford 2004

R. Panzanelli, K. Lapatin and E. Schmidt, *The Colour of Life* (exh. cat) The J. Paul Getty Museum, Los Angeles 2008 (forthcoming).

J. Parnell, *An account of the many fine noble seats I have seen...,* London 1763

Petworth House, West Sussex, The National Trust, London 1987

A. Potts, *The Sculptural Imagination,* New Haven, 2000

A. Radcliffe, 'Acquisitions of Sculpture by the Royal Academy during its first century', *Apollo,* LXXXIX, January 1969, pp. 44–51

B. Read, *Victorian Sculpture,* New Haven 1982

Report of the Select Committee of the House of Commons on the Earl of Elgin's Collection of Sculptured Marbles, London 1816

D.M. Reynolds, *Hiram Powers and his Ideal Sculpture,* New York, 1977

J. Reynolds, *Discourses on Art,* ed. R.R. Wark, New Haven 1975

J.M. Robinson, *The Wyatts: An Architectural Dynasty,* Oxford 1979

Notes to the Introduction

S. von la Roche, *Sophie in London 1786, being the Diary of Sophie von la Roche* (translated from the German, with an introduction by C. Williams), London 1933

L. Roper, *The Gardens of Anglesey Abbey*, London 1964

I. Roscoe, *Dictionary of British Sculptors 1660–1851* (revised edition of R. Gunnis), with contributions by M. G. Sullivan and E. Hardy, New Haven 2009 (forthcoming)

J. Russell, 6th Duke of Bedford, *Outline Engravings and Descriptions of the Woburn Abbey Marbles*, London 1822

E. Salling, 'Canova and Thorvaldsen: A study in contrasts', *Apollo*, XCVI, September 1972, pp. 214–19

D. Saywell and J. Simon (eds.), *Complete Illustrated Catalogue, National Portrait Gallery*, London 2004

J. Scott, *The Pleasures of Antiquity. British Collectors of Greece and Rome*, New Haven 2003

O.S. Scott, *Raby Castle, seat of Lord Barnard, T.D.*, Derby 1972

Sergel (exh. cat.), ed. N.-G. Hökby, U. Cederlöf and M. Olausson, Nationalmuseum, Stockholm 1990

Sergel och Hans Romerska Krets. Europeiska Terrakottor 1760–1814 (exh. cat.), Nationalmuseum, Stockholm, 2004

J.T. Smith, *Nollekens and his Times* (2 vols), London 1828

H. Smithers, *Liverpool: its Commerce, Statistics and Institutions*, Liverpool 1825

J. Spence, *Letters from the Grand Tour* (ed. S. Klima), Montreal 1975

T. Stevens, 'John Gibson's "The Sleeping Shepherd Boy"' in P. Curtis (ed.), *Patronage & Practice: Sculpture on Merseyside*, Liverpool 1989, pp. 57–9

M. Symes, *William Gilpin at Painshill: the Gardens in 1772*, Painshill Park Trust 1994

The Treasure Houses of Britain: Five Hundred Years of Private Patronage and Art Collecting (exh. cat.), National Gallery of Art, Washington, New Haven 1985

M. Trusted (ed.) and C. Milano, *Pistrucci's Capriccio. A rediscovered Masterpiece of Regency Sculpture* (exh. cat), Sir John Soane's Museum and Waddesdon Manor, London 2006

H. Valentine, *From Reynolds to Lawrence: The first sixty years of the Royal Academy of Arts and its collections*, London 1991

G. Vaughan, 'The restoration of classical sculpture in the eighteenth century and the problem of authenticity' in M. Jones (ed.), *Why Fakes Matter: Essays on the Problems of Authenticity*, London 1992, pp, 41–-50

R. R. Villani, 'Il "Busto di Negro" di Francis Harwood del J. Paul Getty Museum di Malibu', *Paragone*, Anno XLII, Nuova Serie, Arte n. 28, 497, 1991, pp. 68–74

G. Waagen, *Treasures of Art in Great Britain …* (3 vols.), London 1854
R. Warner, *The History of Bath*, Bath 1801

T. Whately, *Observations on Modern Gardening*, Dublin 1770

M. Whinney (revised. J. Physick), *Sculpture in Britain 1530 to 1830*, Harmondsworth, 1988

J.J.L. Whiteley, 'Light and Shade in French Neo-Classicism', *Burlington Magazine*, 117, 1975, pp.771–3

W.T. Whitley, *Art in England 1821–1837*, London 1930

D. Wilson, 'A bust of Thomas Hollis by Joseph Wilton RA. Sitter and bust revisited', *British Art Journal*, vol. V, no. 3, pp. 4–26

J.J. Winckelmann, *History of the Art of Antiquity*, tr. H.F. Mallgrave, introduction by A. Potts, Los Angeles 2006

K. Woodbridge, 'Henry Hoare's Paradise', *The Art Bulletin*, 47, No. 1 March 1965, pp. 83–116

A. Yarrington, 'The Female Pygmalion: Anne Seymour Damer, Allan Cunningham and the writing of a woman sculptor's life', *Sculpture Journal*, I, 1997, pp.32–44

A. Yarrington, 'Anglo-Italian Attitudes: Chantrey and Canova' in C. Sicca and A. Yarrington (eds.), *The Lustrous Trade: Material Culture and the History of Sculpture in England and Italy c.1700–c.1860*, Leicester 2000, pp.132–55

A. Yarrington, 'The Three Graces and the Temple of Feminine Virtue', *Sculpture Journal*, VII, 2002, pp.30–43

1. Letter to Abraham Reimbach, 10 January 1826; Cunningham 1843, II, pp.223–4, quoted in Yarrington 2000, p.137.

2. Cited in H. Honour, 'Canova's Three Graces' in Honour and Weston-Lewis 1995, p. 45.

3. This was in addition to his print-making business, also evoking the antique in imaginative but often unhistorical ways.

4. Winckelmann 2006, Part 2, p. 323.

5. Reynolds 1975, p.177.

6. *Report of the Select Committee* 1816, pp. 69 and 78.

7. Cunningham 1831, p. 78.

8. Quoted in Yarrington 2000, p. 137.

9. *Report of the Select Committee* 1816, p. 27.

10. H. Honour, 'Neo-classicism' in *The Age of Neo-Classicism* 1972, p. xxii.

11. Honour 1977, p. 14.

12. Broadly speaking, this period extends from about 1770 to 1830, although some later works can be classified as neo-classical; see for example no. 20, the work of Hiram Powers.

13. See Hawley and Saisselin 1964, pp. 2–15.

14. Reynolds 1975, p. 177.

15. Flaxman 1838, p. 292.

16. Winckelmann 2006, p. 334.

17. Honour 1959, pp .242–3.

18. Sculptors were generally male at this time, though Anne Seymour Damer (1748–1828) was an important British exception; see Yarrington 1997.

19. Cunningham 1831, III, p. 328.

20. See F. Haskell, 'The British as Collectors' in *The Treasure Houses of Britain* 1985, p. 51.

21. *The Life of Benjamin Robert Haydon*, London, 1853, ed. T. Taylor, I, p. 150, quoted in Whitelely 1975, p. 772.

Curator's Acknowledgements

Copyright and Photocredits

Malcolm Baker, Diane Bilbey, Antonia Boström, Rosie Broadley, Chezzy Brownen; Alice Chasey, Roberta Cremoncini, Lucy Cullen, Aileen Dawson, Dai Evans, Chris Gravett, Torsten Gunnarsson, Robin Hamlyn, Yvonne Hardman, Matthew Hargraves, Michael Hatt, Dawn Heywood, Alastair Laing, Andrea Martin, Amy Meyers, Martin Myrone, Magnus Olausson, Clare Owen, Lucy Peltz, Trevor Proudfoot, Ingrid Roscoe, Julian Treuherz, Helen Valentine, Alexa Warburton, Paul Williamson, Alison Yarrington